images *of* nature

The Art of
British
Natural History

Andrea Hart

Published by the Natural History Museum, London

First published by the Natural History Museum, Cromwell Road, London SW7 5BD.
© The Trustees of the Natural History Museum, London 2017. All Rights Reserved.

ISBN 978 0 565 09423 2

A catalogue record for this book is available from the British Library.

Internal design by Mercer Design, London
Reproduction by Saxon Digital Services
Printed by 1010 Printing International Limited

Front cover: *Phalacrocorax carbo*, great cormorant
Back cover: *Alnus glutinosa*, common alder
Back flap: *Cancer pagurus*, edible crab
Title page: *Aequipecten opercularis*, queen scallop
Contents page: *Centaurea cyanus*, cornflower
P1: *Cerura vinula*, puss moth

Note: measurements given in captions are original artwork size.

Contents

Introduction

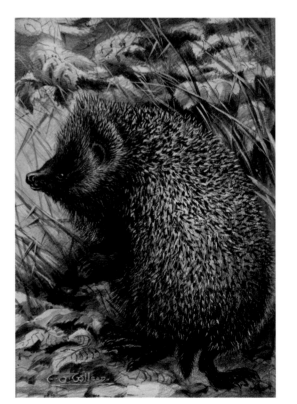

The natural history of the British Isles is a unique and remarkable story. While lacking the larger vertebrate terrestrial megafauna and floras found on other continents, the distinctiveness of the wildlife found on the British Isles has fascinated and inspired generations of natural history enthusiasts for centuries. Its wildlife has played a pivotal role in many a childhood, particularly in storytelling. Some of the British Isles most iconic and best-loved creatures have been brought to life in the beloved children's classic story books: Beatrix Potter's hedgehog, *Mrs Tiggy-Winkle*, Roald Dahl's fox in *Fantastic Mr Fox* and the delightful and eccentric characters of Toad, Ratty, Mole and Badger from Kenneth Grahame's *Wind in the Willows*. These wonderfully anthropomorphised characters help kindle an early interest and connection with nature amongst readers.

For many, an interest nurtured from an early age through words, pictures or physical interactions with nature created a desire to continue to explore, understand and document its diversity and processes. The comprehensive body of knowledge, accumulated as a result of this over many centuries, and which continues to be added to, is crucial for our understanding of the natural world and its future conservation and sustainability.

This book uses the extensive artwork collections of the Natural History Museum's Library and Archives to explore the natural diversity of the British Isles and capture how its geology, flora and fauna have been observed, documented and illustrated. It also presents a visual showcase that demonstrates the incredible skill of natural history artists spanning the last 300 years and celebrates the amazing diversity of our British wildlife.

The changing face of British flora and fauna

The British Isles have a rich geological past created over a long and complex history of geological events, which not only laid the foundations for a wide range of economic resources but has strongly influenced its plant and animal diversity. Rocks of almost all of the major geological time periods are represented within the complex geological layers of the British Isles. Four of the names of these periods are directly linked with British history – the Cambrian (named after Cambria the latinised form of Cymru, the Welsh name for Wales), Devonian (named after the county of Devon), and the Ordovician and Silurian (named after the Celtic Welsh tribes, the Ordovices and the Silures). These names reflect the dominance of British geologists in the formulation of the geological timescale during the early nineteenth century. It was also English geologist William Smith (1769–1839) who first recognised that rock layers or strata, and the fossil assemblages contained within them, represented successive geological time periods. Smith published the first geological map of England, Wales and part of Scotland in 1815 (see p6). The map was based on his observations of rocks during his employment as a canal surveyor and through his extensive travels around the country. Remarkably, 200 years since its publication, the map still remains an accurate representation of the geology of Great Britain.

The occurrence and distribution of the flora and fauna of the British Isles have been influenced by the ice ages, episodes of extreme temperatures and the periodic land bridges that joined the British Isles to the European mainland, prior to them becoming fully isolated following the last glacial retreat around 10,000 years ago. Species migrated from the European continent during the periods when the land bridges existed and so many British species are subspecies of those found in Europe. The geographical positioning and temperate climate of the British Isles have also influenced the range and diversity of its wildlife and vegetation, and being situated at the edge of the continent also means that they provide an important and popular visiting ground for migratory birds, much to the delight of ornithologists.

There are few endemic or native species in the British Isles due to the periods of glaciation and so many species, especially plants, have been introduced over time. New species of plants were much-sought-after during the late eighteenth and nineteenth centuries, and Britain saw the largest increase in plant introductions during this period as a result of expeditions and explorations to previously unexplored parts of the globe. While the increase in global travel and new methods of transportation such as the Wardian case (a hermetically sealed, portable mini-greenhouse) helped exotic plants survive longer journeys, these advances also opened the door for many pests and invasive species. The impact of introduced species – intentional or accidental – has not always been advantageous

OPPOSITE: *Erinaceus europaeus*, west European hedgehog

The hedgehog, with its array of spines, is one of the most iconic British mammals but its numbers are thought to be in serious decline, with habitat loss being a contributing factor. Each spine lasts for about a year then drops out and a replacement grows. Their poor eyesight is compensated by their very acute sense of smell and, surprisingly, they are good at swimming and climbing.

Edward Wilson (1872–1912)
Watercolour on paper
1905–1910
250 x 174 mm

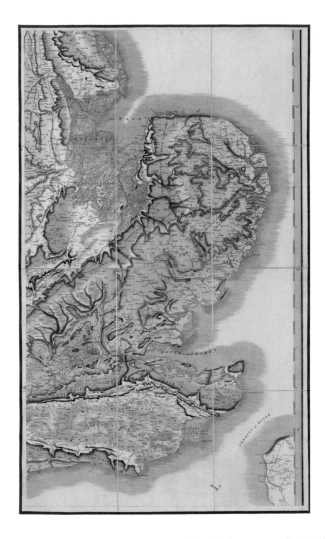

to British wildlife. Many non-native species are harmless but some invasive plants such as the Japanese knotweed, *Fallopia japonica*, and animals like the grey squirrel, *Sciurus carolinensis*, signal crayfish, *Pacifastacus leniusculus*, and the American mink, *Neovison vison*, have had devastating effects on native species, decimating populations through predation, outcompeting native species for habitats and resources and causing environmental damage. Some invasive species carry diseases such as potato blight and Dutch elm disease, which are not only a threat to native biodiversity but also have a detrimental effect on economic interests such as agriculture, forestry and fisheries. Today, native species continue to decline in numbers and some, including the ash tree, *Fraxinus excelsior*, are facing extinction, while introduced or alien species thrive.

In recent years, the effects of climate change have become increasingly evident, affecting the habits of insects, species breeding patterns and the flowering and fruiting periods of plants. Hedgehogs, for example, have seen a drastic decline in numbers during the past 70 years with the cause attributed, in part, to warmer winters affecting their hibernation periods. The Invasive Non-Native Special Framework Strategy for Great Britain (2015) predicts that climate change will continue to have a substantial impact on biodiversity in the coming years and will continue to affect the distribution of native species and enable non-native species to become more common.

Society has an equally significant effect on the British landscape, its ecosystems and, subsequently, the array of plants and animals that live within them, which has led to species change and extinction. While the effects of industry and the economy appear to be most evident during the past century, humans have long controlled and manipulated nature to the extent that few areas of true wilderness now exist. While Britain was once covered in ancient woodland, a 2016 report maintained that it is now one of the least wooded nations in Europe with only 10 percent of England now covered in trees. The first Enclosures Act in 1760, which set in motion the Agricultural Revolution, the drying out of wetland ecosystems for commercial and agricultural development along with other forms of habitat destruction, have all affected and in some cases, decimated the ranges of wildlife populations. The

Species Recovery Trust estimates that 421 species have become extinct in England since 1814. Some extinctions are more recent than others, for example species of wasps, beetles, dragonflies, butterflies and fungi. Others are evidenced in the fossil record and include the cave lion and woolly mammoth as well as those documented in historical records such as the elk, Eurasian lynx and wild boar. The last grey wolf in England was observed in 1680.

Two habitats in which the natural vegetation has been least transformed or altered are the coastline and mountains. Coastal vegetation in particular has long held an attraction to botanists due to its varied habitats and changing conditions, in which a large variety of plants grow and have adapted to the unusually harsh surroundings. Home to many rare and beautiful plants, the coast is a place where plant succession is most evident due to the varying environmental conditions and limited disruption by the activities of humans. It was on such ecosystems that Barbara Nicholson (1906–1978) based her drawings of British floristic habitats. Commissioned by the Natural History Museum as part of an educational poster series, her beautiful compositions not only demonstrated the floristic diversity found within the varied habitats of the British Isles, which include grasslands and moorlands, but most importantly the illustrations were scientifically accurate in their representations of the plant species that grow within them.

Closer to home, the deliberate planting of native plants and their close relatives dates back to Roman times. For thousands of years, gardens have not only been places for the cultivation of ornamental plants and crops but have also become wildlife havens for nature. While they might be fragmented and man-made, these artificial environments have long provided opportunities to observe and encourage wildlife. The countryside, however, remains the desired habitat for the majority of British species, even though many plants and animals have adapted to living and surviving in urban areas. Although small pockets of green space continue to exist in our towns and cities, it is not until one leaves these urban areas that one can truly observe the unpredictability and beauty of the natural world. Regardless of the constraints placed upon it by humans and our inescapable dependency upon it, nature and its inhabitants will always find a way of changing or acting around that control.

Documenting British natural history

The publication of books on natural history, especially British natural history, spans the history of printing as well as the history of communication, human endeavour, art, culture, religion, philosophy and politics. Studies of the natural world were undertaken long before the advent of movable type in the early fifteenth century. One such example is Pliny's *Historia Naturalis*, the Natural History Museum

OPPOSITE: Single section (one of nine) of William Smith's geological map titled, *A Delineation of the Strata of England and Wales, with part of Scotland geological map*

Smith was the first to recognise that layers of rocks found in the ground followed specific patterns and from his observations discovered that he could predict the location of strata in different sites. In 1815 he published the first geological map of Britain. Each copy of the map was hand-coloured using no fewer than 20 colours to differentiate the various strata in addition to a fading colouring technique to indicate the age of the rocks (the darker the shading, the older the strata).

William Smith (1769–1839)
Hand-coloured engraving
1815
1055 x 630 mm

OPPOSITE: *Eryngium maritimum*, sea holly

The sea holly is typically found in mobile sand dunes and can grow up to 2.4 m (8 ft) long. Its leaves are stiff and leathery, which helps to reduce the amount of transpiration that occurs during periods of water shortage. Hodgson's drawing is from a specimen that he found in Littlestone, a sandy beach located near New Romney in Kent.

Robert Durie Hodgson
(active 1909–1947)
Graphite on paper
1913
253 x 202 mm

Library's oldest book. Surviving in manuscript form until it was printed in 1469, it was written in Latin by Pliny (AD23–79) prior to his death with the aim of recording everything that was known on natural history at the time. Once the ability to print in substantial quantities had become possible, studies of the natural world could be made more widely available. The increased access to knowledge proved significantly influential to many of the great naturalists as it triggered their interests and passions, especially for particular groups of animals or plants.

Early printed books were expensive and considered a luxury, and for those without the finances to afford them outright, books would often be shared or borrowed. The cost of production was often prohibitive, particularly given the expense of printing the text using the relief process (printing from a raised printing block), and then having to separately print the accompanying illustrations using the intaglio process (the opposite of relief where the image is incised into the surface usually in the form of an engraving and the ink remains in the grooves). Books that did contain illustrations were, however, able to shed additional light on the many social aspects of the development of natural history from the formation of societies to the countless voyages, expeditions and personal endeavours undertaken for the cause of furthering knowledge. While the quantity of literature on the natural history of the British Isles is vast, it was, and remains, sometimes difficult to publish, especially if the subject matter is little studied or has a restricted appeal, regardless of the quality of information it contains.

Some of the most finely produced and lavish natural history books were published during the nineteenth century, particularly books focusing on avifauna, or birds. One of the most outstanding examples was Lord Lilford's *Coloured Figures of the Birds of the British Islands* published from 1891 to 1897. Thomas Littleton Powys, 4th Baron Lilford, had amassed an extensive aviary of live birds at his residence at Lilford Hall, Northamptonshire, which included many rare species. One of the eight founders of the British Ornithologists' Union in 1858, he was responsible for the introduction of the little owl, *Athene noctua*, from Italy into England in the 1880s. The main illustrator of Lilford's work was the Scottish artist Archibald Thorburn (1860–1935), a skilled wildlife artist who held a life-long love of birds. Thorburn painted 268 watercolours for the publication, five of which are held in the Library's collections. The Museum also holds 18 watercolour drawings of mammals by Thorburn.

The recording of plants grown in the British Isles dates back to the twelfth century when individuals observed and documented their surroundings in the form of localised records. Much of what was written in the early accounts was confined to local areas as people tended to be born and to die in the same village. This was true of the Reverend Gilbert White (1720–1793) whose observations of the natural world around the village of Selborne, Hampshire where he lived, not only inspired, but also significantly influenced, the recording of British natural history. White was characteristic

of the early British natural historians many of whom were clergymen who studied nature in order to learn more about God and his creation. Motivations aside, the culmination of White's observations enabled him to complete one of the most original works on natural history ever published. Titled *The Natural History of Selborne* (1789), the publication was based solely on his meticulous observations in the parish, with the aim of providing information to the reader in a way in which he could express the 'life and conversations of animals'.

The originality of White's work lies in the fact that it was based on his correspondence over a period of 14 years with two eminent naturalists of the time, Thomas Pennant (1726–1798) and Daines Barrington (1727–1800). The letters cover his observations and natural history related questions and musings. Regarded as novel at the time, this style of record-keeping – of noting observations in journals and recording nature first-hand such as the appearance of birds, the germination and flowering of plants and other phenomena – proved a vital inspiration for future field observation and scientific writing methods. It also demonstrated the importance

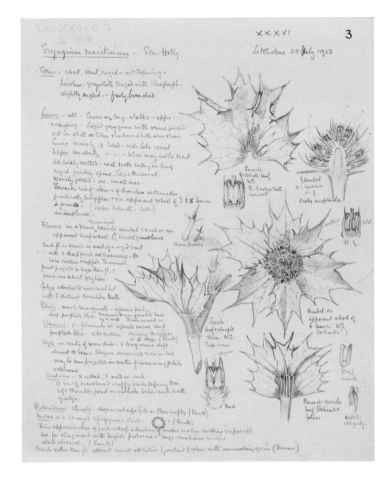

of individual contributions to the body of cumulative scientific knowledge. The continuing appeal of White's work lies in the vivid accounts and clarity of his writing, and ability to bring natural history to life through other senses, rather than simply visual description, based on observation. Through his work, White was able to enthuse and extol the virtues and pleasures of losing oneself in nature. A decade after White's publication, Alexander von Humboldt (1769–1859), one of the most famous naturalists ever, set off on his travels to Latin America. This life changing expedition not only helped Humboldt lay the foundations for many modern branches of science including biogeography, but enabled him to develop an holistic understanding of nature that was not just based on scientific observation and measurements but also feelings and emotional responses to the world around him, similarly to White. Humboldt's publications were to inspire and influence generations of thinkers, authors, poets and naturalists including Charles Darwin (1809–1882), who idolised him.

Accurately documenting and establishing the current status of all British species and maintaining these records remains an ongoing challenge. The proliferation of British natural history societies and field clubs since the mid-eighteenth century and their continuation of scientific research have become vital, especially for species monitoring. Regional or county recorders, such as members of the Botanical Society of the British Isles, report on the flora of local areas, while other monitoring programmes exist for other specific groups of wildlife such as the Bat Conservation Trust, Natural England or the British Trust for Ornithology. Organised data collection is crucial, since no one individual's knowledge of every species is always possible, available or sufficient.

Specialist societies and organisations continue to play an important role in providing discussion forums, offering learning opportunities, informing policy decisions and encouraging and engaging the public's enjoyment and knowledge of the natural world with wildlife issues. They have also helped highlight threats to British wildlife resulting from habitat decline or destruction, or through the introduction of foreign species. Some have also been instrumental in the successful reintroduction and re-establishment of populations of British species that previously suffered major declines or extinction. Recent programmes have included the reintroduction of the white-tailed eagle, *Haliaeetus albicilla*, in east Scotland, the red kite, *Milvus milvus*, in England and Scotland, the corncrake, *Crex crex*, at The Royal Society for the Protection of Birds Nene Washes reserve, Whittlesey, and butterfly species including the Large Blue, *Maculinea arion*, reintroduced to the British Isles using stock from Sweden.

A milestone in scientific progress was the advent of the microscope – the history and uses of which can be followed in the printed word and through illustration. Invented in the 1620s, it was not until the 1660s that it became used extensively for research, enabling scientific theory, observation and investigation to be carried out on a previously unimaginable level, revealing previously unseen detail. Antoine van Leeuwenhoek (1632–1723) was one of the first pioneers and biological users of the microscope for his observations of bacteria and protozoa. But it was British-born Robert Hooke (1635–1703), whose *Micrographia* published in 1665 with the depictions of his microscopic observations, that consolidated the role of the microscope in understanding biology. Hooke's publication, made more attractive due to the inclusion of his intricate engravings, also demonstrated the power of the book in attracting the wider public's interest, not only in microscopy but to a previously hidden natural world.

The use of a microscope was key to Gulielma Lister's (1860–1949) groundbreaking work on Myxogastria, or slime moulds, which she undertook with her father Arthur Lister. Her studies of this little-researched forest-dwelling organism were accompanied by illustrations that she drew throughout her numerous research notebooks. Lister donated these to the British Mycological Society – of which she

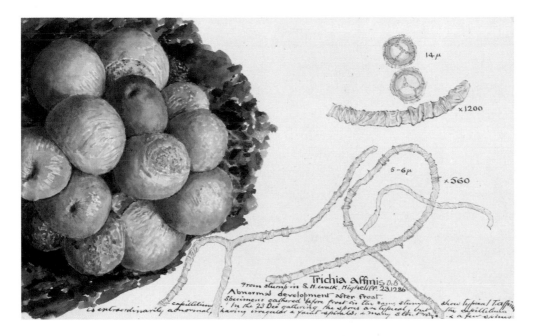

LEFT: *Trichia affinis*, slime mould (Myxogastria, Amoebozoa)

Slime moulds are gigantic amoebae that can join up and slowly crawl through soils or on the trunks of trees hunting for their food that includes algae, fungi and bacteria. Lister was an expert in Myxogastria (slime moulds) and worked closely with her father on them. Together they published many groundbreaking works on this group, many of which are supported by her scientifically detailed illustrations.

Gulielma Lister (1860–1949)
Watercolour on paper
1886
156 x 255 mm

was a founding member and served as President between 1912 and 1932. The Irish zoologist, Edward Waller (1803–1873) also employed the use of a microscope for his studies of British foraminifera (small, primarily marine organisms), which he collected by dredging in the North Sea, for his 1867 *Report of the British Association for the Advancement of Science*. The report was accompanied by his striking black and white illustrations, similar in symmetry and style to those of German biologist Ernst Haeckel in his influential publication *Kunstformen der Natur* (1899–1904), which helped popularise foraminifera and in particular radiolarians (protozoa that are found as zooplankton in oceans). Smaller still were Albert D. Michael's (1836–1927) now classic studies of the British oribatida (a type of soil mite), ranging in size from 0.2 to 1.4 millimetres. One of the most abundant and diverse groups of animals living in soil, these mites are considered harmless to humans and plants. Their feeding habits help increase the breakdown of organic matter in soil making them important organisms in the maintenance of soil health and fertility. Michael's specimen and microscopic slide collections, together with the original illustrations for his monograph, *British Tyroglyphidae* are held by the Museum.

Today, we are fortunate that almost all books and journals are accessible either in their original printed format or electronically. While many books have disappeared from the market and can only be found in library collections, efforts by libraries and publishers to make them available online have been considerable, particularly in the last decade, through non-profit collaborative efforts such as the Biodiversity Heritage Library. Technology has certainly opened up our accessibility to the natural

world, far beyond the scope that even Charles Darwin or Alfred Russel Wallace could ever have imagined. Combined with the ease of accessibility to the rich natural diversity afforded by the British Isles, the invention of printing enabled the mass documentation of natural history and provided the fundamental starting block to facilitating shared knowledge and understanding of the natural world.

Illustrating British natural history

The earliest artworks depicting British natural history in the Museum's Library and Archives collections are by Johann Dillenius (1684–1747), Eleazar Albin (fl. 1690–c. 1742), and Peter Brown (active 1758–1799). Professor of Botany at Oxford and a peer of Carl Linnaeus (1707–1778) the Swedish naturalist and taxonomist, Dillenius created elegant and detailed botanical pen-and-ink illustrations, which he accompanied with annotations, but which were never published. Albin was one of the earliest and greatest zoological book illustrators of the eighteenth century. His publication A Natural History of Birds (1731–1738) was the first British bird book to be illustrated entirely with hand-coloured plates and Brown was famous for illustrating insects, birds and shells – many of which he drew on vellum, a parchment made from calf skin. Vellum was a favourite medium for many historical artists as it enabled them to achieve a finer detail and almost three-dimensional quality to their work. Butterflies and shells were the most popularly illustrated and collected natural history subjects during this period.

During the eighteenth century, visual representation of subjects became crucial in advancing scientific knowledge. For the purposes of science, the ideal was to have an accurate descriptive text to accompany and complement an image to provide the fullest account of the subject possible. Accuracy was vital. While written text can be used in isolation, if either an illustration or its accompanying text is inaccurate or unclear, it is useless and could lead to misinterpretation or species misidentification. Hearsay and textual descriptions of species never seen, and illustrations based only on parts of an animal, occasionally led to false accounts of mythical creatures. Interestingly, many illustrations have outlived their text descriptions as new scientific knowledge and understanding has emerged.

It was not until the establishment of botanical gardens in Europe in the seventeenth century that the focus towards the scientific study of plants gained a firm foothold. The illustrations found in early herbals – books on the medicinal properties of plants – were frequently accompanied by crude wood block prints many of which were copied from one publication to the next. The development of printing techniques eventually enabled finer detail to be achieved, giving rise to the clearer and more accurate depiction of illustrations that scientific progress dictated to aid the correct species identification. In recent times, with the burgeoning capabilities of digital technology, the techniques

to produce images have changed significantly, but what remains unchanged is the original skill of the artist creating the work. While the dictates of scientific illustration impose some restraint on artists enforcing a somewhat systematic, mechanical process of delineation of a subject, many illustrations stand alone as artworks in their own right, appreciated purely for aesthetic pleasure.

To create a convincing and accurate illustration, it is essential that the illustrator has an understanding and appreciation of their subject, something that can only be achieved through careful observation. For scientific illustration, especially in zoological illustration, this may include the ability to indicate movement and life, as well as capturing the key taxonomic aspects that make the subject identifiable. Prior to the mass availability of the microscope, microscopic detail was not achievable for early zoological illustrators, and so their illustrations were more portrait-like in composition. Nonetheless, many were scrupulous in their portrayal of details that were visible to the human eye. Variations in illustrations could also arise if the artist observed their subject alive or dead. For her remarkable illustrations on British fishes, Sarah Bowdich (1791–1856) would sit at the river's edge and wait for live fish to be caught so she could capture their true colour, as their colour fades quickly when they die.

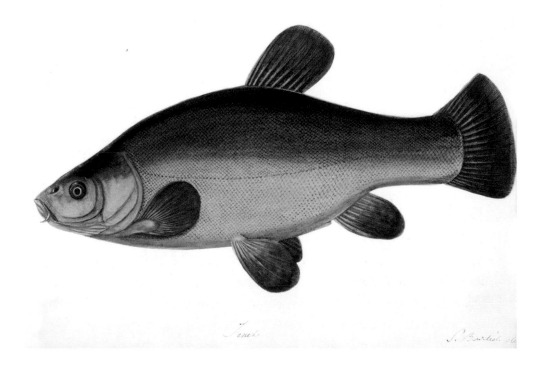

LEFT: *Tinca tinca*, tench

The tench is a fresh and brackish water fish that is brown-green in colour with golden sides, a cream coloured belly and two barbels (whiskers) at the corners of its mouth. Bowdich made every effort to see the fish subjects she drew fresh so that she could verify what information she could about them, especially their colour, which fades quickly once the fish dies.

Sarah Bowdich (1791–1856)
Watercolour on paper
c. 1828
274 x 343 mm

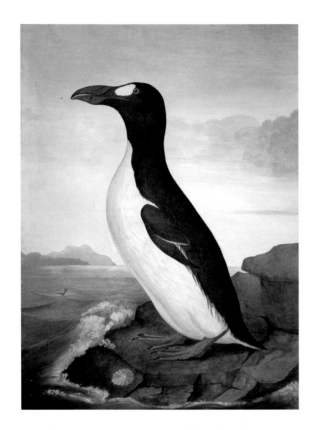

ABOVE: *Pinguinus impennis*, great auk

MacGillivray painted this illustration of the great auk in 1839, five years before the species became extinct. He based his drawing on a specimen in the Natural History Museum and another that belonged to the American ornithologist John James Audubon.

William MacGillivray
(1796–1852)
Watercolour on paper
1839
770 x 560 mm

The styles and motivations of the artists who illustrate British wildlife vary considerably depending upon what they set out to achieve, as individual observers of nature, or what they were required to convey if employed for a commission for publication, or for a gallery for example. Both Moses Harris (1730–1788) and Margaret Fountaine (1862–1940) illustrated their studies of the life cycles of insects. Harris's were large and bold and intended for entomological publications, while Fountaine's illustrations, which were captured in her personal notebooks, were small and delicate but still precisely detailed. William MacGillivray's (1796–1852) depictions of birds and mammals were similar in style to those of his good friend John James Audubon (1785–1851). Both artists portrayed their subjects life size, imbuing their artworks with a sense of dynamism, and capturing the precarious nature of animal life in the wild. One of the most noted and gifted British ornithologists, but overshadowed in part by the success of Audubon's *Birds of America*, MacGillivray based his classifications upon his anatomical investigations and observations of his subjects in real life. Franz Bauer was a master of botanical illustration and using a microscope enabled him to achieve a level of detail in his illustrations of British orchids that remains unsurpassed, and is greatly admired and studied by contemporary botanical artists. What all their illustrations have in common is their realism and the considerable information they impart, as well as their beauty.

A further distinct style of illustration is that used in field guides, published to help amateur naturalists identify plants and animals and which became popular in the twentieth century due to their portability. For the mainstream audiences, Frederick Warne's *Wayside and Woodland* series of books covered many natural history subjects ranging from seashore flora and fauna to books on specific animals or plant groups, and which have since become collectable classics partly due to their vibrant but scientifically accurate illustrations. There was also an increase in the publication of regional faunas and floras but with limited local interest. Another style of illustration, primarily used for taxonomic identification and individual treatments of a genus, is the use of pen-and-ink line drawings which allows the artist to create strong areas of contrast and therefore enable a more detailed anatomical and morphological illustration to assist identification. Spider illustrations by artists such as Michael Roberts (b.1945) and Frank Hinkins (1852–1934) created notable examples of this technique. Roberts

and Hinkins illustrated complete species guides to complement the accompanying text description, producing some of the most comprehensive accounts of spider species found in the British Isles, which remain unequalled in accuracy and quality.

The illustration of palaeontological and geological specimens is quite distinct from drawing living species as different criteria are applied to classifying fossils, rocks and minerals. As a result, these types of illustrations rarely possess the charm or beauty of other areas of natural history subjects, despite the skill of the artist. Accuracy in illustration still remains paramount for scientific investigation. This is demonstrated in the illustrations of fossilised remains by palaeontologists and comparative anatomists James Parkinson, Richard Owen and George Brettingham Sowerby. Entering the world of palaeo-reconstruction, however, an artist's imagination becomes somewhat central to their depiction of prehistoric animals and scenes, albeit based on available fossil evidence. The results, however, have not always been accurate. Neave Parker's (1910–1961) ink wash illustrations are clear examples of this. Created in the 1950s, Parker's illustrations of dinosaurs, of which eight once lived in Britain, were based on the current thinking as to how these dinosaurs would have looked or stood. Fifty years later, new fossil evidence and investigation demonstrate that almost all his illustrations contain some anatomical errors.

Through studying the natural history artwork collections held in the Museum's Library and Archives, it becomes clearly evident that there is no perfectly objective way of drawing or illustrating the wonderful diversity of nature. But through ensuring that each new generation is encouraged and inspired to hold an appreciation, respect and regard for the environment, the future of maintaining and sustaining British species diversity will continue.

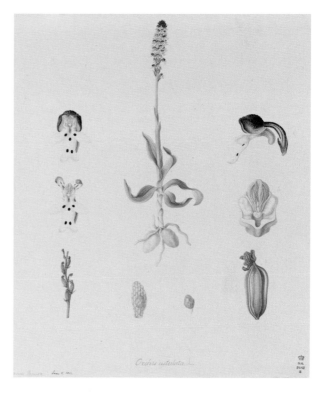

ABOVE: *Neotinea ustulata*, burnt-tip orchid

The burnt-tip orchid gets its common name from the darker colouration of its unopened flower, which gives it a 'burnt' effect. Although it can be found in larger colonies in Wiltshire, the plant is considered endangered in Britain. A master of botanical illustration, Austrian-born Bauer was the first permanent resident artist at Kew Gardens in London.

Franz Bauer (1758–1840)
Watercolour on paper
1811
464 x 311 mm

Bibliography

ALLEN, David E. *Books and naturalists*. Collins, 2010.

HAWKSWORTH, David L. (ed). *The changing wildlife of Great Britain and Ireland*. Taylor and Francis, 2001.

KNIGHT, David. *Zoological illustration: an essay towards a history of printed zoological pictures*. Dawson/Archon Books, 1977.

WILLIAMSON, Tom. *An environmental history of wildlife in England, 1650–1950*. Bloomsbury, 2013.

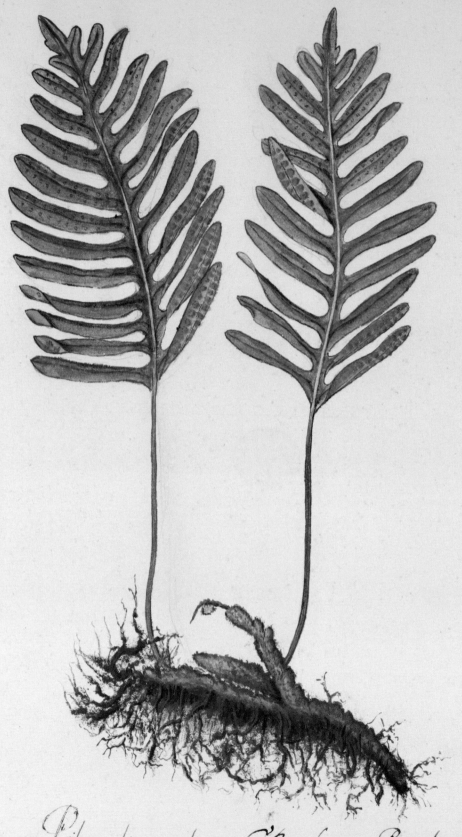

Polypodium vulgare C. Bauh. 954. Perpetuo viret.
Hieme excrescentiæ floridæ enascuntur & ser folia apparent,
Majo matura fiunt; utrumque imagine demonstratur. 1720.
Januario.

Polypodium vulgare, common polypody

German-born Dillenius moved to England in 1721 where he was appointed Sherardian Chair of Botany at Oxford in 1734, the first holder of the chair. This illustration is one of the earliest in the Natural History Museum's collections.

Johann Jacob Dillenius (1684–1747)
Watercolour on paper
1720
279 x 223 mm

Pinguicula lusitanica; *Carex pauciflora*, pale butterwort, few-flowered sedge

The insectivorous pale butterwort, *Pinguicula lusitanica*, is locally common in much of the west of the British Isles and western Europe. *Carex pauciflora* is rarer and is largely restricted to Scotland and Northern Ireland where it mainly lives in sphagnum bogs. This illustration was featured in John Lightfoot's *Flora Scotica* (1777), being described as, 'discovered by Mr Lightfoot in bogs half way up the mountain Goatfell, in Arran'.

Moses Griffiths (1749–1819)
Graphite on paper
1775
186 x 117 mm

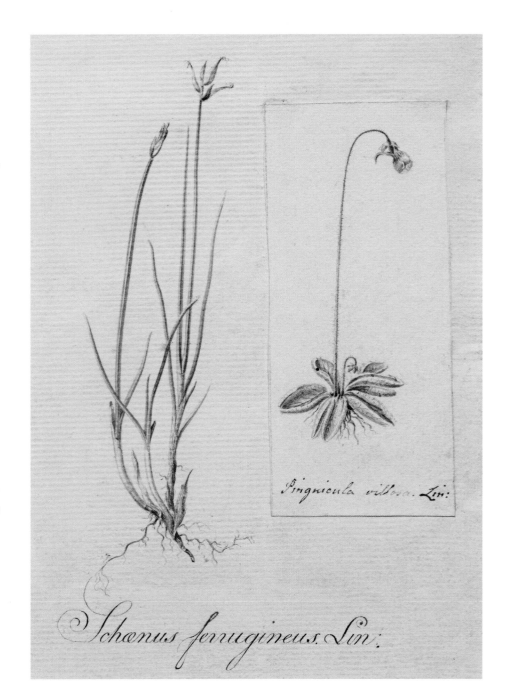

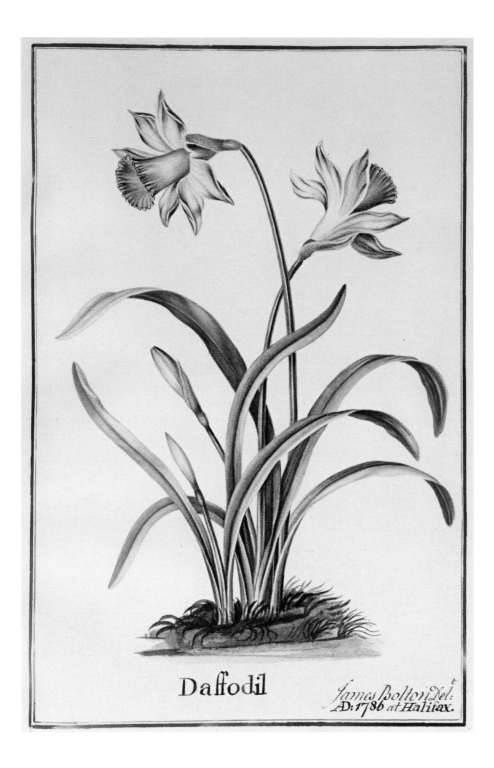

Daffodil

James Bolton Del:
AD: 1786 at Halifax.

Narcissus pseudonarcissus, wild daffodil

The national emblem of Wales, the wild daffodil has seen its native populations in the British Isles decrease substantially since the nineteenth century, due to increasing areas of land taken up with agriculture, woodland clearance and bulbs being uprooted for gardens. This ink and wash illustration was of a specimen growing in Halifax, England where the artist lived.

James Bolton (1735–1799)
Ink and wash on paper
1786
362 x 233 mm

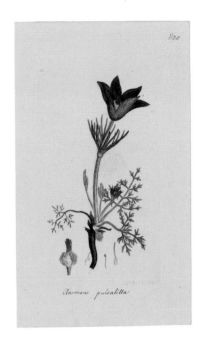

Pulsatilla vulgaris, pasqueflower

The pasqueflower is a member of the buttercup family and can grow 10–13 cm (4–5 in) tall. It is a rare sight to see as there are only 19 populations of this flower left in the British Isles. Over 2,500 watercolour illustrations were made by Sowerby and his family for the publication *English Botany* (1790–1813). The original illustration is shown here on the left accompanied by the engraving of the first edition and lithograph of the third edition of the series.

James Sowerby (1757–1822)
Watercolour on paper
c. 1790–1792
360 x 544 mm

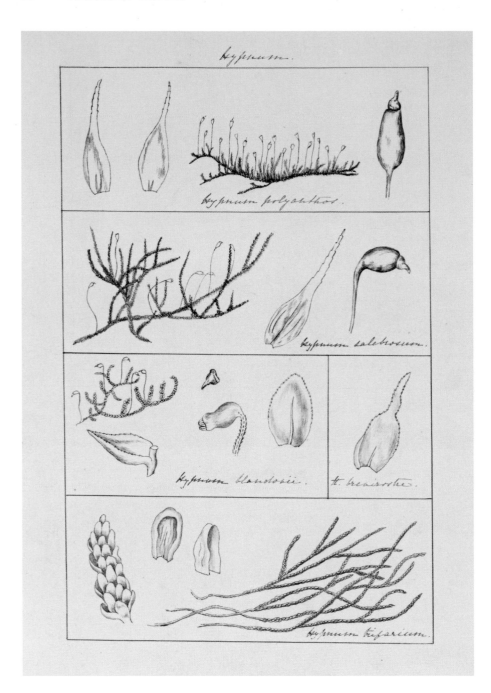

From top to bottom: *Pylaisia polyantha*, many-flowered leskea; *Brachythecium salebrosum*, smooth-stalk feather-moss; *Helodium blandowii*, Blandow's tamarisk-moss; *Loeskeobryum brevirostre*, short-beaked wood-moss; *Pseudocalliergon trifarium*, three-ranked spear-moss

Edwards was a talented engraver who specialised in line engravings and portraits. His ability was highly praised by William Hooker and Thomas Taylor in their publication *Muscologia Britannica; containing the mosses of Great Britain & Ireland* (1818), for which Edwards engraved the plates. In their introduction, Hooker describes how their researches were made possible by, 'Frequent leisure, various journeys made purposely through various parts of our happy islands...'. This illustration was published as a supplementary plate in the second edition (1827).

William Camden Edwards (1777–1855)
c. 1820s
Ink on paper
279 x 223 mm.

Leucanthemum vulgare, oxeye daisy

Hawkins wrote detailed and accurate descriptions to accompany her drawings. Positioned on the opposite side of each sheet they demonstrated her knowledge of the subjects of her drawings. She was a competent botanist and provided a comprehensive botanical account for William Robertson's *A Hand-book of the Peak of Derbyshire* (1854). Hawkins wrote of this daisy, 'The whole plant is slightly aromatic, with an unpleasant smell'.

Ellen Hawkins (d.1864)
Watercolour on paper
1828
264 x 207 mm

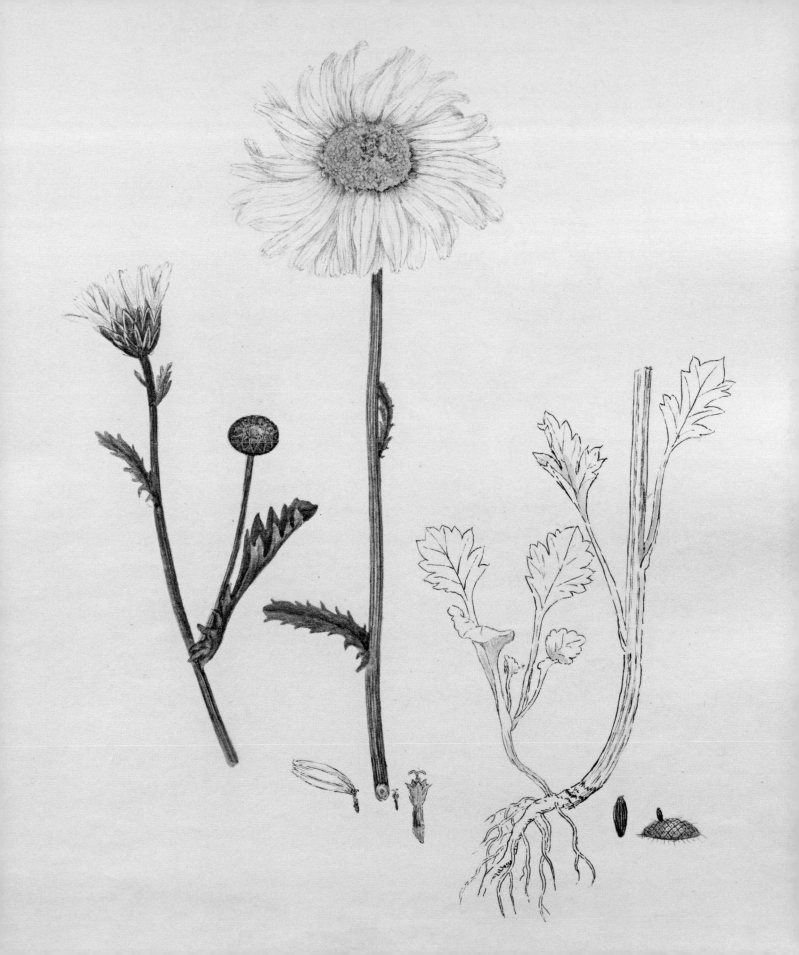

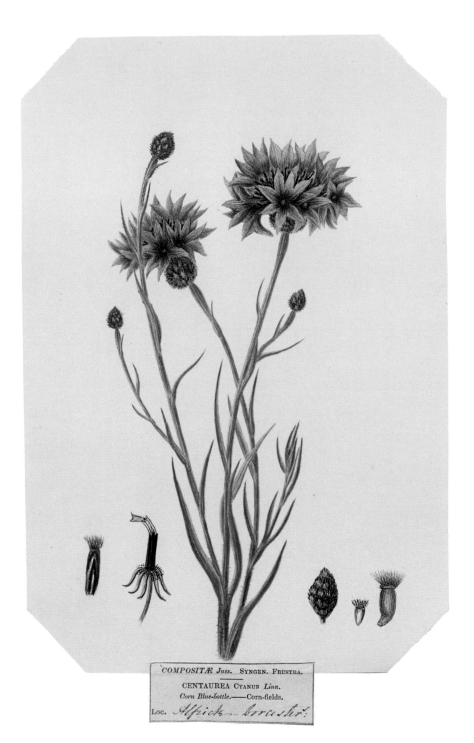

Centaurea cyanus, cornflower

The cornflower is an annual flowering plant and is known to have been present in the British Isles since the Iron Age. Due to habitat destruction and the over-use of herbicides it is now considered to be endangered in its native habitat. Moseley lived in Worcestershire where she illustrated and collected plants. Her plant specimens were purchased by the Natural History Museum in 1886 and included taxa like this cornflower that are now rare in the British Isles.

Harriet Moseley (active 1836–1867)
Watercolour on paper
c. 1836–1848
223 x 151 mm

Papaver rhoeas, common poppy

This poppy's scientific name is made up of the Latin word *Papaver* meaning food or milk and the Greek work *rhoeas* meaning red. A common flower in cornfields, its seeds can lie dormant for over 80 years lying deep beneath the soil until germinating en masse once the soil gets disturbed.

Harriet Moseley (active 1836–1867)
Watercolour on paper
c. 1836–1848
225 x 150 mm

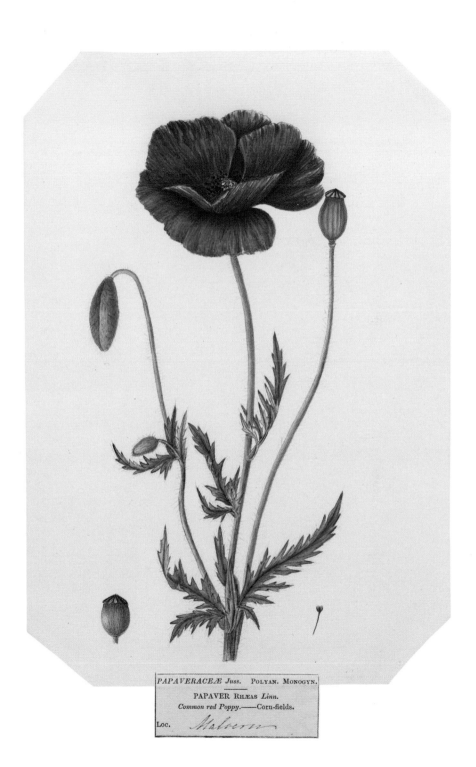

PAPAVERACEÆ *Juss.* POLYAN. MONOGYN.

PAPAVER RHÆAS *Linn.*
Common red Poppy.——Corn-fields.

Loc. *Malvern*

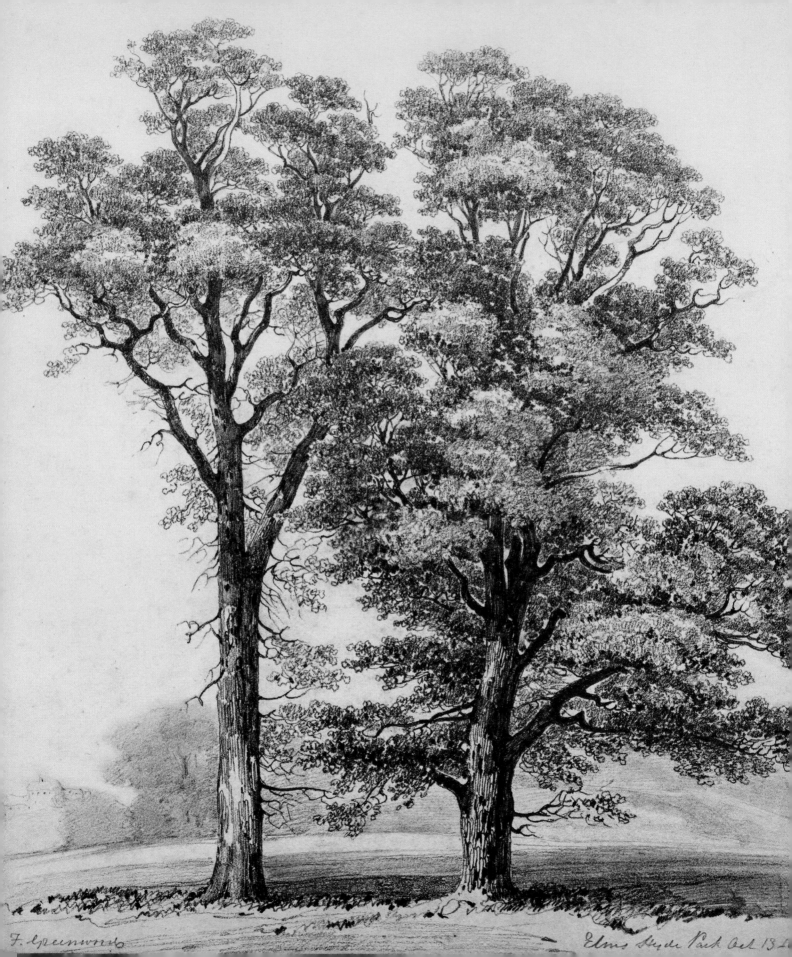

F. Greenwood Elms Hyde Park Oct 13

Ulmus, elm

This illustration of elm trees in Hyde Park was completed on 13 October 1837. Fine elm trees were once numerous in Hyde Park but were destroyed by Dutch elm disease, a fungal disease that arrived in Britain in 1927. A more lethal strain of the disease appeared in the late 1960s causing the loss of an estimated 25 million trees in Britain.

F. Greenwood (dates unknown)
Graphite on card
1837
415 x 329 mm

From top left clockwise: *Osmundea pinnatifida*; *Chondria dasyphylla*; *Cordylecladia erecta*; *Gastroclonium ovatum*, red seaweeds or rhodophyta

Red algae, or rhodophyta, are one of the oldest groups of eukaryotic algae. *Osmundea pinnatifida* is an aromatic seaweed that is dried and used as a spice in Scotland. Christopher Edmund Broome is best known as a mycologist, who along with the Reverend Miles Berkeley (who at the time was the leading British authority on fungi and plant pathology) described almost 550 species of fungi.

Christopher Edmund Broome (1812–1886)
Watercolour on paper
c. 1840s
187 x 112 mm

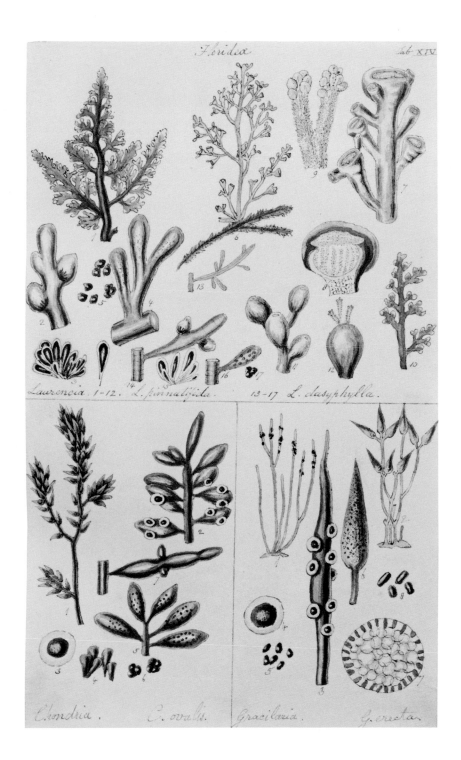

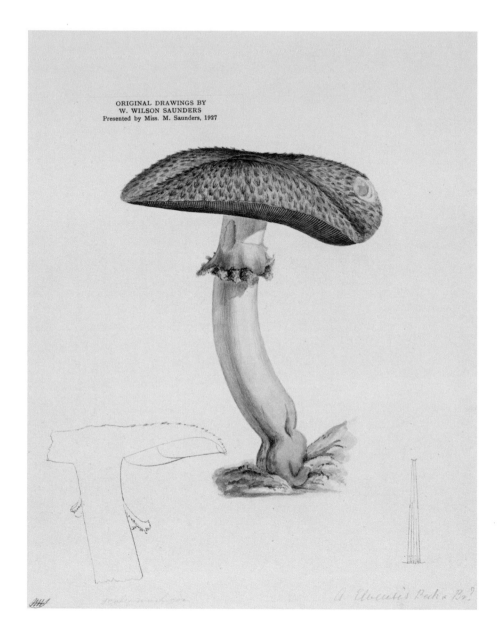

ORIGINAL DRAWINGS BY
W. WILSON SAUNDERS
Presented by Miss. M. Saunders, 1927

Agaricus sp.

Due to the lack of any colour staining on the stem of this illustration its taxonomic identification at species level is uncertain. Compared to plants, fungi have not been as well studied and so their taxonomy is less stable and complete. Saunders worked as an insurance broker but had strong interests in both botany and entomology. A Fellow of the Royal Society from 1853, he also held the appointments of the President of the Entomological Society and of the Treasurer of the Linnean Society.

William Wilson Saunders (1809–1879)
Watercolour on paper
1849
256 x 203 mm

Tripleurospermum inodorum, corn feverfew

Considered a weed to arable crops and a host for several insect pests, the corn feverfew is a source of nectar and pollen beneficial to insects. This illustration is from a collection of three volumes of watercolour drawings of the flora of Yorkshire by an unidentified artist – it was drawn from a specimen found in Melton Bottoms, Yorkshire on 18 June 1856.

Artist unknown
Watercolour on paper
1856
224 x 150 mm

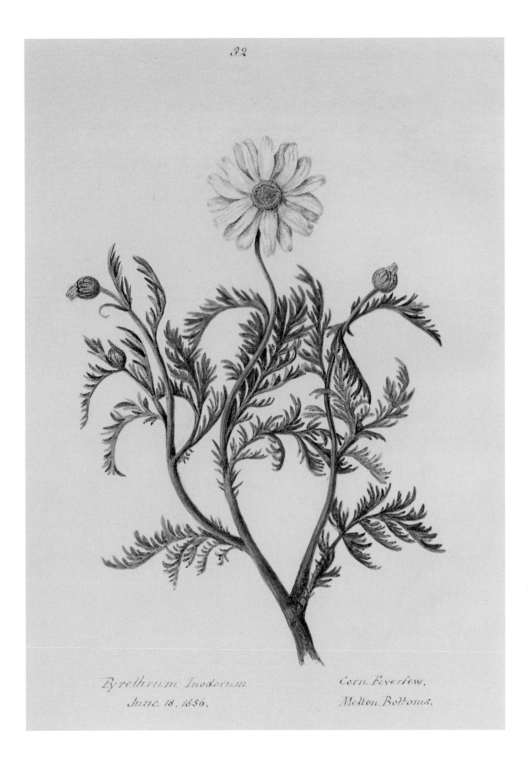

Amanita strobiliformis, warted amanita

Smith was originally apprenticed as an architect prior to becoming a freelance artist. His particular expertise was fungi, which he collected, studied, drew and published over 200 articles and papers, and several books about. There are approximately 15,000 known species of fungi in the British Isles. Whether *Amanita strobiliformis* is edible or not remains uncertain.

Worthington George Smith (1835–1917)
Watercolour on paper
1866
747 x 540 mm

Chlorophyllum rhacodes, shaggy parasol

Chlorophyllum rhacodes is an impressive mushroom due to its large size. It has a shaggy and scaled cap and its flesh turns pinkish orange when the stem is sliced. Stebbing, along with Gulielma Lister (1860–1949) and Annie Lorrain Smith (1854–1937) were proposed as some of the first women fellows of the Linnean Society in 1904 – they were formally admitted in January 1905.

Mary Anne Stebbing (d.1927)
Watercolour on paper
1895
284 x 226 mm

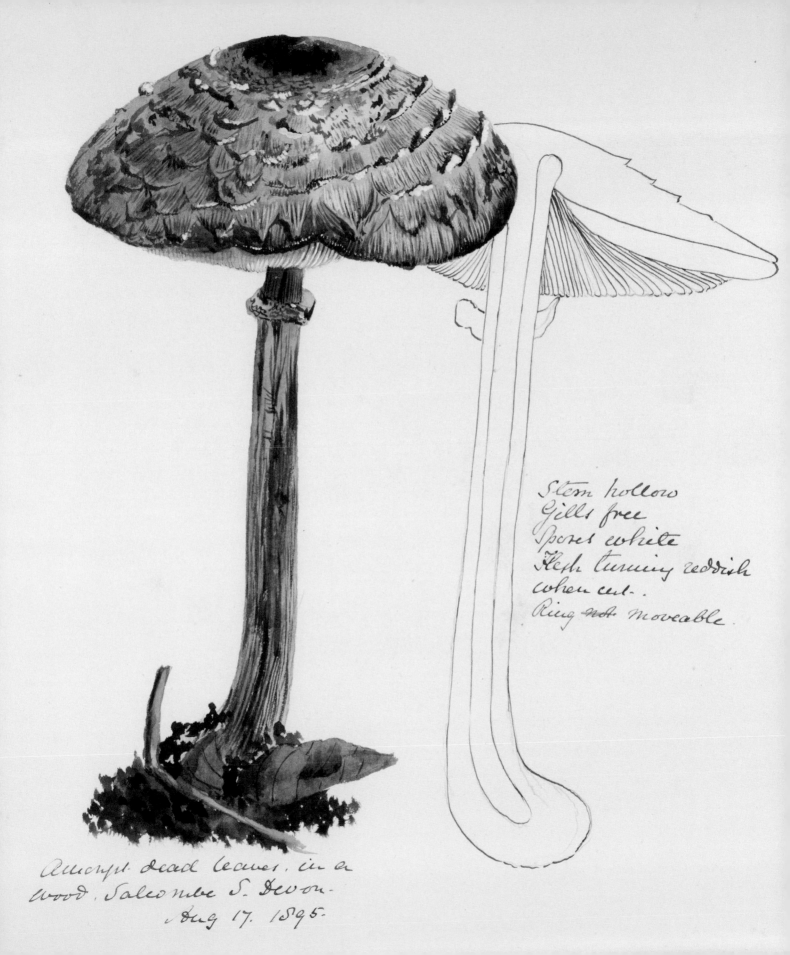

Stem hollow
Gills free
Spores white
Flesh turning reddish
when cut.
Ring not moveable

Amongst dead leaves, in a
Wood, Salcombe S. Devon.
Aug 17. 1895.

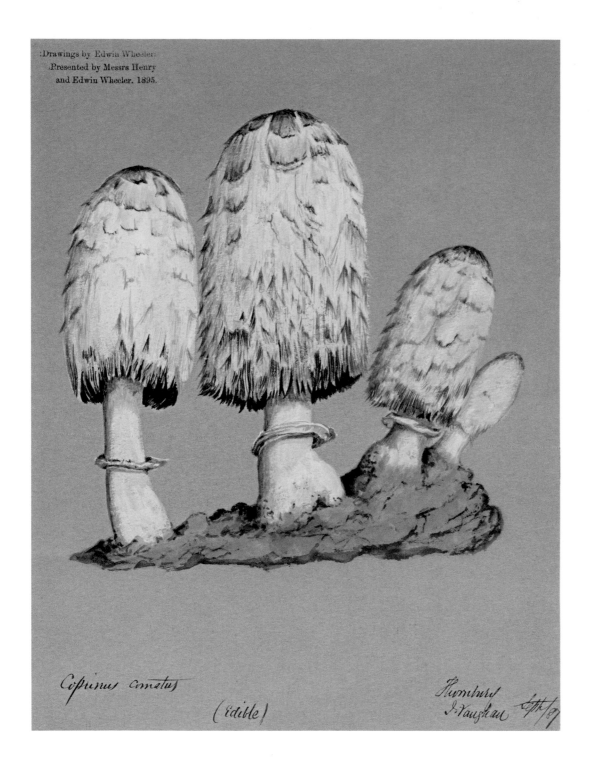

Drawings by Edwin Wheeler:
Presented by Messrs Henry
and Edwin Wheeler. 1895.

Coprinus comatus

(edible)

Thornbury
J. Vaughan Sept/87

Coprinus comatus, shaggy ink cap

As it matures, the gills of the shaggy
ink cap blacken as the mushroom starts
to autodigest to enhance the release
of its spores. The process causes the
decomposition of the fungus and
production of a black inky liquid. This
'ink' was how this species got its common
name as the ink was historically used
for writing.

Edwin Wheeler (1833–1909)
Watercolour on paper
1897
259 x 159 mm

Quercus robur, pedunculate oak with
cherry gall of *Cynips quercusfolii*, cherry
gall wasp

This illustration comes from a collection of
drawings of 261 British wildflowers that were
presented to the Natural History Museum
in 1983. It features the gall from *Cynips
quercusfolii*, a tiny black gall wasp that lays
its eggs in dormant oak buds. Insect galls are
abnormal growths found on plants and are
caused by the plant's hormone reaction to
the feeding or egg-laying of certain insects
and mites.

Laura Burrard (b.1832–1897?)
Watercolour on paper
c. mid-nineteenth century
97 x 78 mm

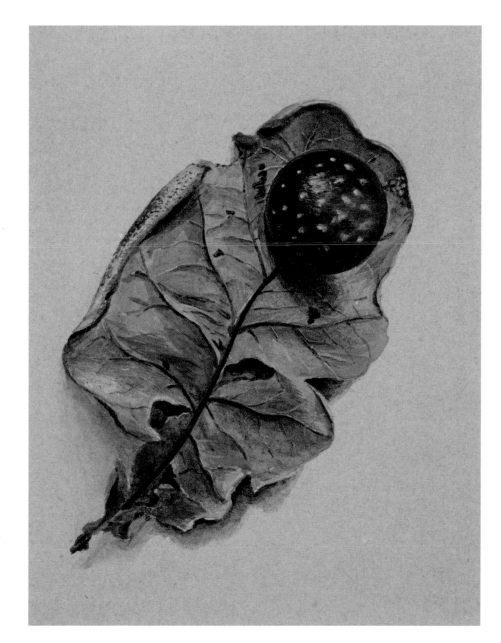

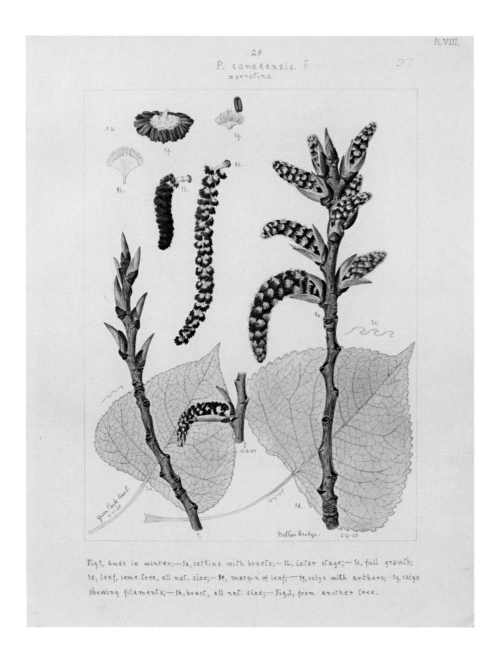

Populus x *canadensis* 'Serotina', black-Italian poplar

This deciduous tree was introduced to Britain from France in 1750, although it was originally cloned in Italy, hence the common name. Widely planted in urban spaces, it was once the commonest of all the poplar hybrids but has become increasingly rare due to its short-lived nature.

Florence Helen Woolward (1854–1936)
Watercolour on paper
1905
315 x 253 mm

Epipactis purpurata Sm., violet helleborine

Godfery specialised in drawing orchids and provided the illustrations for her husband's comprehensive taxonomic work on British orchids. This illustration was drawn from a specimen growing in Guildford, Surrey on 7 September 1916.

Hilda Margaret Godfery (1871–1930)
Watercolour on paper
1916
276 x 187 mm

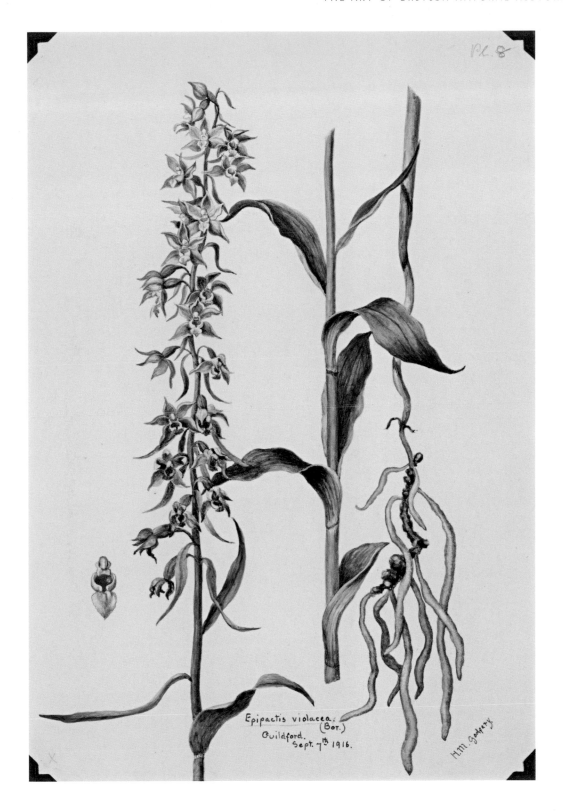

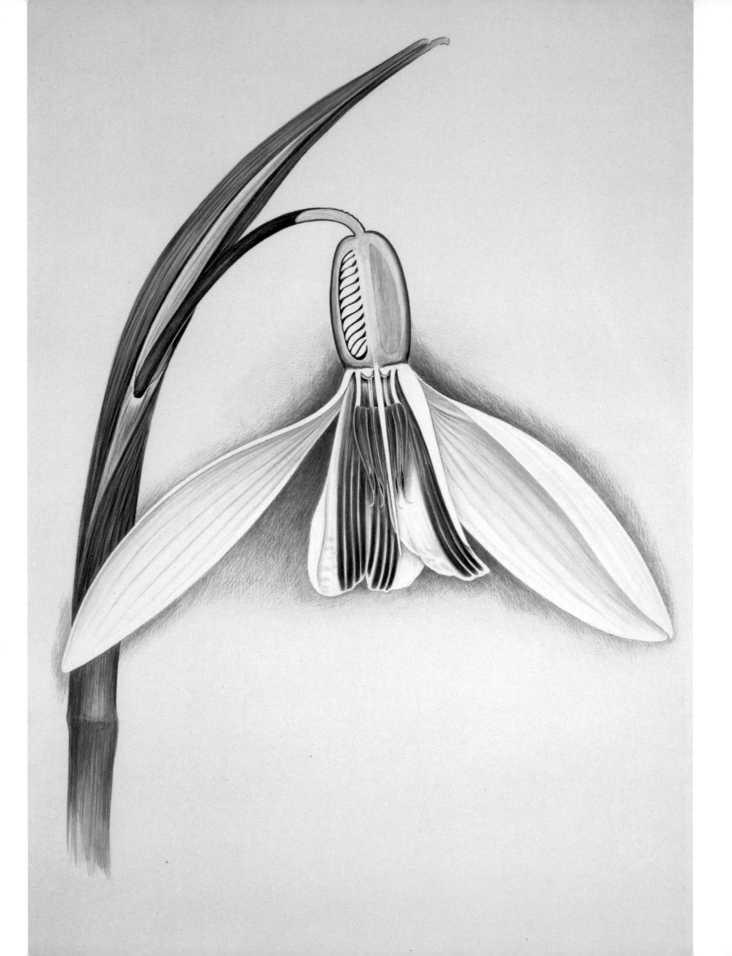

Galanthus nivalis, common snowdrop

The snowdrop is celebrated as a sign of spring and has the epithet *nivalis* meaning 'of the snow'. Church specialised in comparative plant morphology and for his magnified illustrations of flowers he insisted each subject was perfect before painting it. After expertly slicing through the flower with a scalpel, Church painted this snowdrop at 4x magnification to demonstrate its floral morphology and flowering mechanism.

Arthur Harry Church (1865–1937)
Watercolour on card
1918
388 x 317 mm

Alaria esculenta, dabberlocks

This edible seaweed can grow up to 2 m (6½ ft) long. In Ireland it is known as Láir or Láracha. It grows very fast and has a high sugar content, which has attracted research into its potential for possible application as a biofuel, especially bioethanol.

Arthur Harry Church (1865–1937)
Pen and ink on card
1918
388 x 317 mm

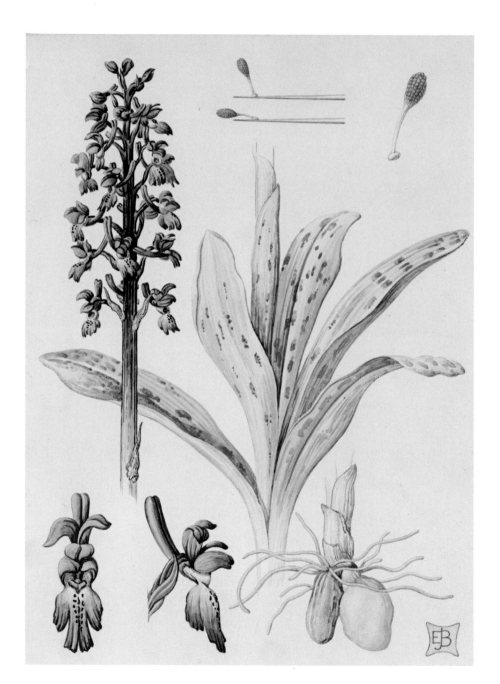

Orchis mascula, early-purple orchid

Found in woodlands, hedgerows and grasslands, as its name suggests, the early-purple orchid is one of the earliest flowering orchids, appearing from April to June. Bedford was born in Lewes, East Sussex and was a keen naturalist and photographer.

Edward Bedford (1866–1953)
Watercolour on card
1920–1921
265 x 190 mm

Alnus glutinosa, common alder

The common alder is regarded as a pioneer species because of its ability to colonise vacant land. It also plays an important role in ecological succession with *Frankia alni*, a nitrogen-fixing bacterium, as together they improve soil fertility.

Beatrice Olive Corfe (1866–1947)
Watercolour on paper
c. 1920/30s
287 x 187 mm

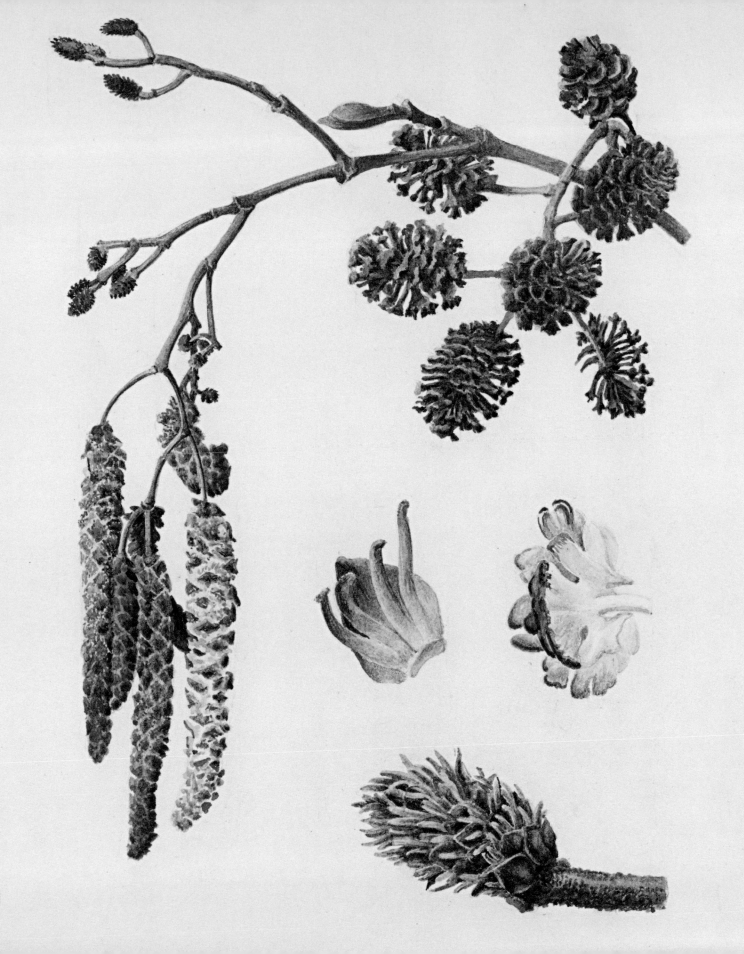

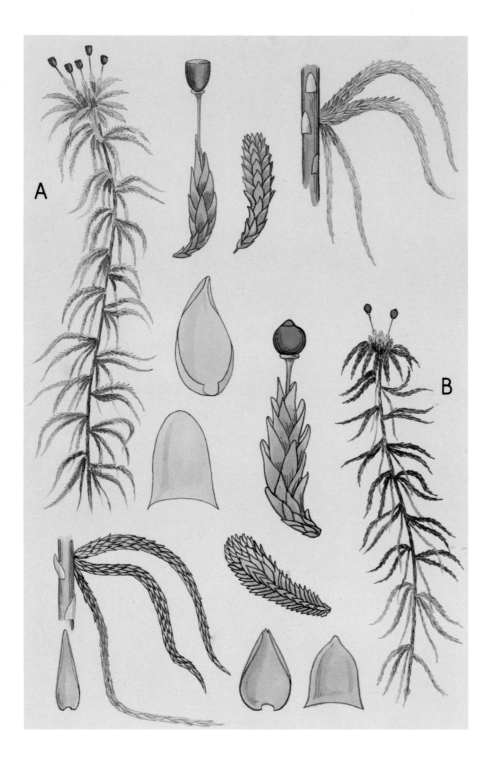

A. *Sphagnum subsecundum*, slender cow-horn bog-moss; B. *Sphagnum capillifolium* subsp. *rubellum*, red bog-moss

There are around 120 species of peat mosses in the genus *Sphagnum*. Peatlands provide important habitats for a wide variety of flora and fauna while also helping to alleviate flooding, improve water quality by filtering, and store carbon. Peat accumulates at a very slow rate but due to its historical extraction for compost, along with the drainage and heavy grazing of peatlands, they are now in serious decline and so the restoration of British lowland peat bogs is now a pressing issue.

Ernest C. Mansell (active 1960s)
Watercolour on paper
c. early 1950s
263 x 190 mm

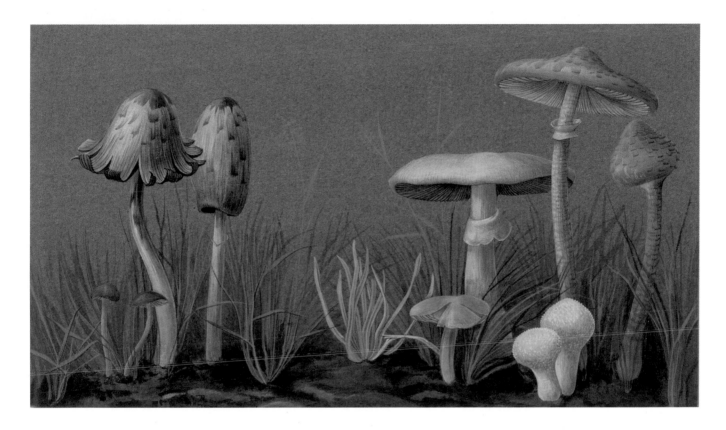

From left to right: *Rugosomyces* sp., domecaps; *Coprinus comatus*, shaggy ink-cap or lawyer's wig; *Clavulinopsis* sp., yellow club; Perhaps *Tricholoma sulphureum*, sulphur knight; *Agaricus arvensis*, horse mushroom; *Lycoperdon perlatum*, common puffball; *Macrolepiota procera*, parasol

Bownas is best known for her textile designs but she also undertook botanical studies and was commissioned by the Natural History Museum to produce illustrations for the then Botany Gallery, which was open from 1962 to 1982. This illustration is from a series of paintings that she completed with artist Gretel Dalby showing the fungi of grassland, and deciduous and coniferous woodlands.

Sheila Bownas (1925–2007)
Watercolour on board
c. early 1960s
178 x 305 mm

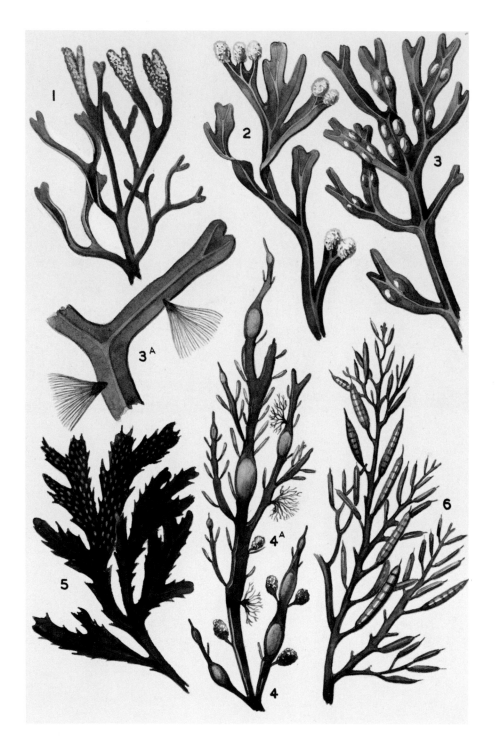

1. *Pelvetia canaliculata*; 2. *Fucus spiralis*; 3. *Fucus vesiculosus*; 3A. *Elachista fucicola*; 4. *Ascophyllum nodosum*; 4A. *Vertebrata lanosa*; 5. *Fucus serratus*; 6. *Halidrys siliquosa*, sea wracks

Seawracks are seaweeds in the family Fucaceae, which all have 'wrack' as part of their common name. There are many economic uses of seaweeds ranging from cosmetics and therapeutic treatments to fertiliser. *Fucus vesiculosus* was the original source of iodine that was discovered in 1811 by the French chemist Bernard Courtois.

Ernest C. Mansell (active 1960s)
Watercolour on paper
c. early 1960s
282 x 193 mm

Fagus sylvatica, common beech

The common beech is a large, deciduous tree, native to southern England and South Wales. Everard was one of the twentieth century's leading botanical artists and enjoyed a successful career as a commercial artist undertaking many private commissions including providing illustrations for published books.

Barbara Everard (1910–1990)
Watercolour on paper
1970
381 x 280 mm

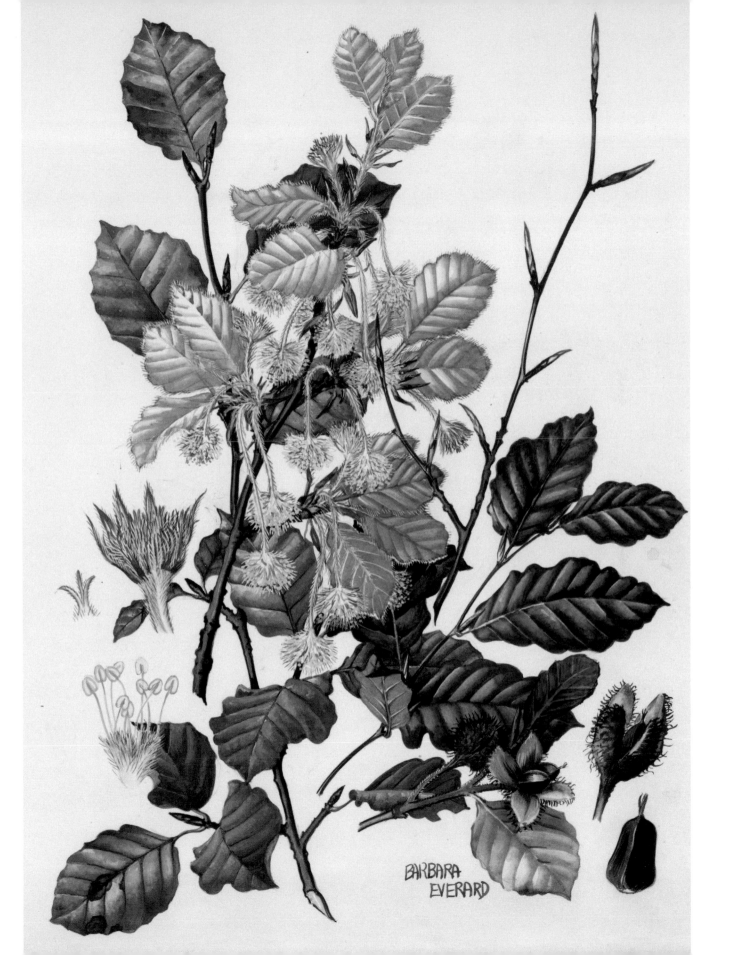

BARBARA
EVERARD

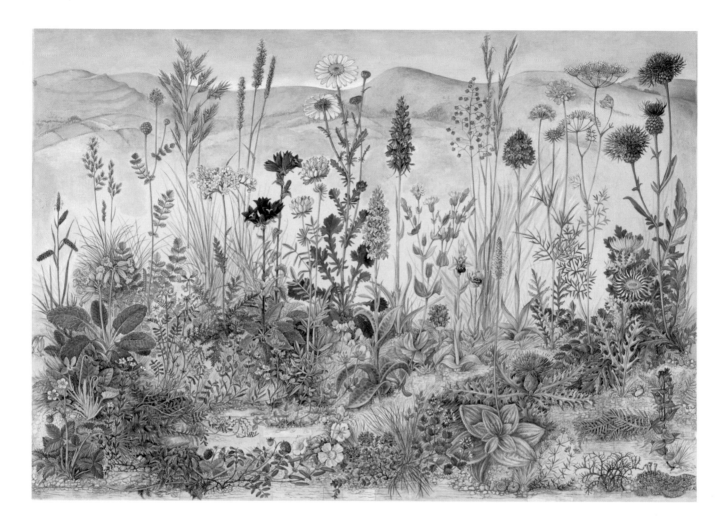

Plants found on Chalk downs including: *Viola hirta* and
Cirsium acaule, hairy violet and dwarf thistle

One of Britain's leading plant illustrators, Nicholson had a talent
for painting accurate portraits of British ecosystems. This was
recognised by the Natural History Museum in the late 1970s,
when it commissioned her to paint a series of educational posters
to represent the United Kingdom's ecology and biodiversity, and
highlight the importance of conserving wild plants in their natural
habitats.

Barbara Nicholson (1906–1978)
Watercolour on board
c. 1970–1977
630 x 827 mm

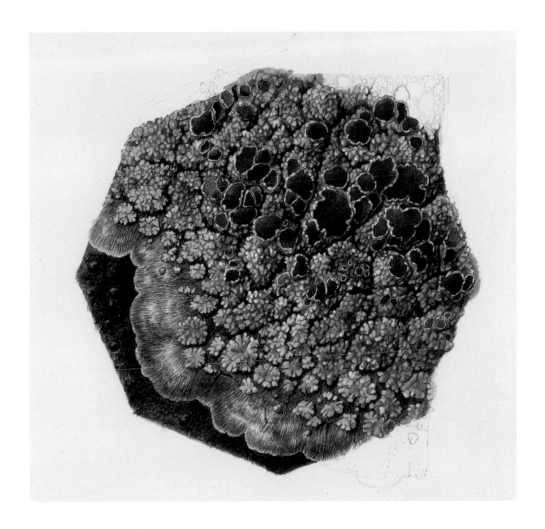

Lecanora poliophaea, lichen

There are various lichen growth forms that include crustose (crust-like), squamulose (scaly), foliose (leafy), fruticose (bushy or shrubby) and leprose (powdery). This lichen has a growth form that is crustose, which means it tightly attaches itself to the rocks where it is found. Born in Fife, Dalby's artistic interests are in forms, textures and colours, which she shows in her illustrations through the use of light and shade to demonstrate the structure and appearance of her subjects.

Claire Dalby (b.1944)
Watercolour on paper
1980
189 x 195 mm

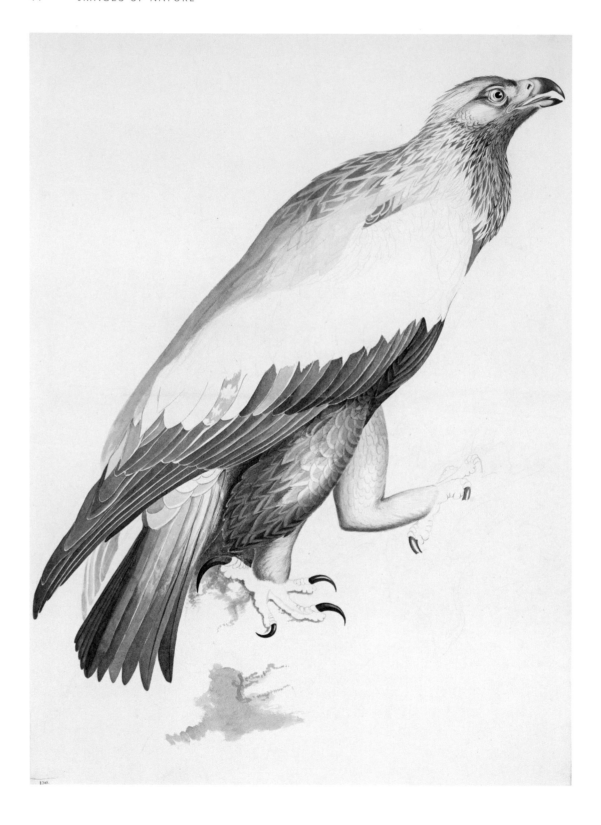

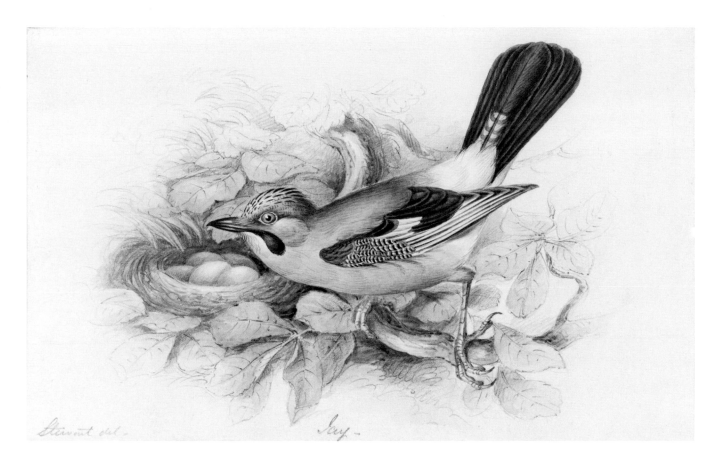

Aquila chrysaetos, golden eagle

It is presumed this illustration was intentionally left unfinished as there is a completed watercolour of a golden eagle in the Museum Library's collection. MacGillivray wrote of 'great havoc had been made among the lambs by the eagles' on his uncle's farm – one of the main reasons these birds have historically been illegally killed and persecuted to the point of extinction. It now only survives in small populations in Scotland.

William MacGillivray (1796–1852)
Graphite and watercolour on paper
c. 1830s
992 x 686 mm

Garrulus glandarius, Eurasian jay

The jay is a member of the crow family, Corvidae. It is a relatively shy bird that feeds mainly on nuts, seeds and insects. It has a particular liking for acorns and hazelnuts, which it buries in the autumn months in order to retrieve them during the winter for food.

James Hope Stewart (1789–1883)
Watercolour on paper
c. 1830s
107 x 172 mm

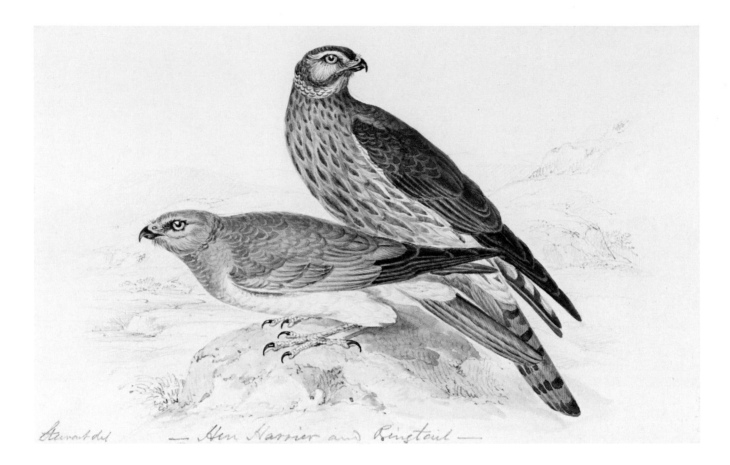

Circus cyaneus, hen harrier male and female

Known as sky dancers due to their elaborate aerial displays,
hen harriers are one of England's most threatened birds of
prey. They have long suffered illegal persecution due to their
predation of grouse used for shooting. Land-use changes,
pesticide use and failed breeding attempts mean their numbers
have never recovered, and so their status remains critical.

James Hope Stewart (1789–1883)
Watercolour on paper
c. 1830s
107 x 172 mm

Falco peregrinus, peregrine falcon

Renowned for its pace, the peregrine falcon can reach speeds of over 200 mph (322 kmph) making it the fastest animal in the world. Stewart was a Scottish natural history artist who prepared nearly 550 illustrations of birds, mammals and insects for Sir William Jardine's 40-volume series, *The Naturalist's Library* (1833–1843).

James Hope Stewart (1789–1883)
Watercolour on paper
c. 1830s
172 x 107 mm

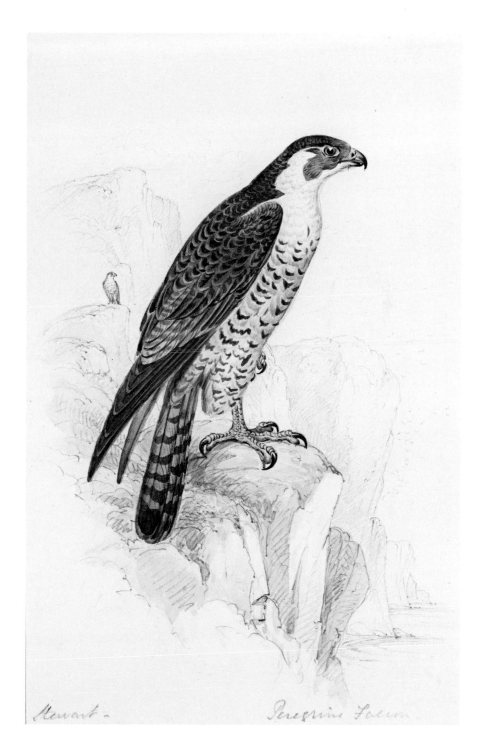

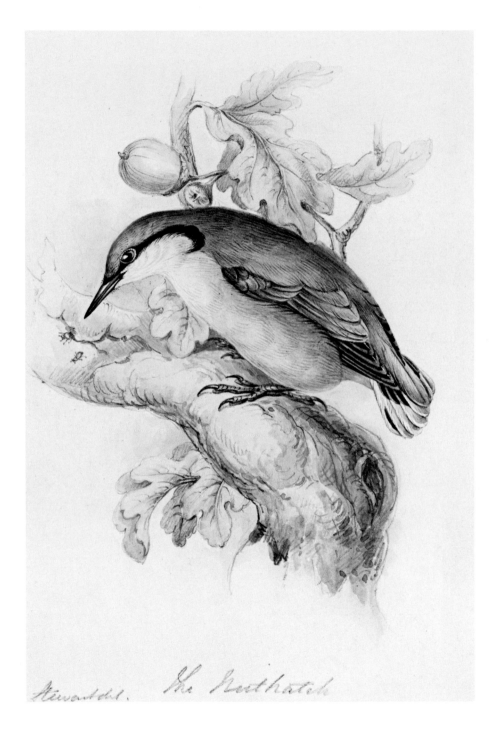

Sitta europaea, Eurasian nuthatch

The nuthatch belongs to the order Passeriformes, a notable feature being the arrangement of their toes – three pointing forward and one back, which helps them to perch. Nuthatches mainly feed on insects, in particular caterpillars and beetles, and can forage along tree trunks and branches both descending head first as well as climbing upwards. They also hoard food all year round, hiding seeds in trees for retrieval in colder weather.

James Hope Stewart (1789–1883)
Watercolour on paper
c. 1830s
172 x 106 mm

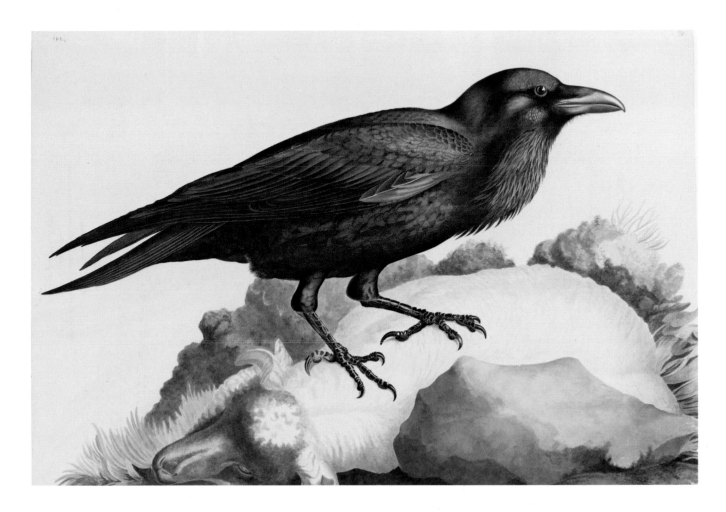

Corvus corax, common raven

Similarly to the American ornithologist John James Aududon,
MacGillivray would often shoot his subjects before he drew them.
This illustration is of an adult male raven that was shot in Edinburgh.
Ravens are opportunistic feeders and so will feed on carrion such as
the sheep in this illustration, which MacGillivray did not illustrate as
finely as the bird.

William MacGillivray (1796–1852)
Watercolour on paper
1832
482 x 687 mm

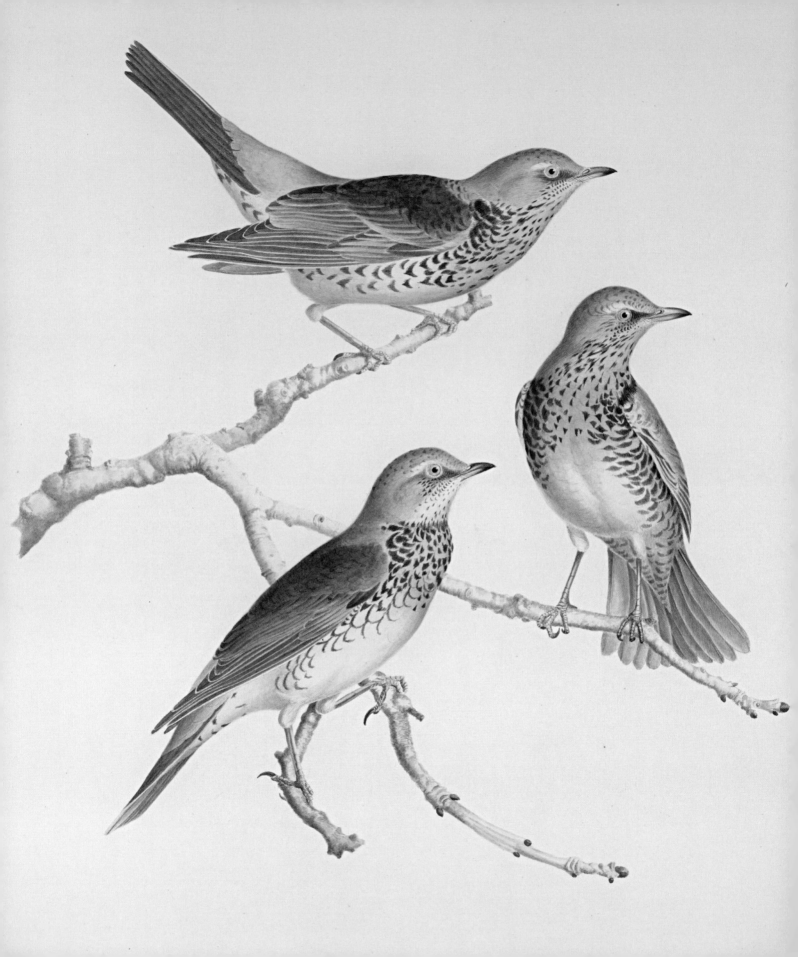

Turdus pilaris, fieldfare

The fieldfare is a common autumn migrant to the British Isles usually arriving in October through to the end of November from their breeding grounds in northern and eastern Europe. Their habitat preference is open countryside and so they are not commonly found in gardens unless the winter weather is particularly harsh.

William MacGillivray (1796–1852)
Watercolour on paper
1833
578 x 460 mm

Sylvia borin, garden warbler

The garden warbler is a spring and summer visitor to the British Isles, it is strongly migratory and winters in sub-Saharan Africa. Cotton was an ornithological writer and artist who privately published two books on British songbirds prior to emigrating to Australia in 1843. This original watercolour was published in *The Song Birds of Great Britain* (1835).

John Cotton (1801–1849)
Watercolour on paper
1834
244 x 175 mm

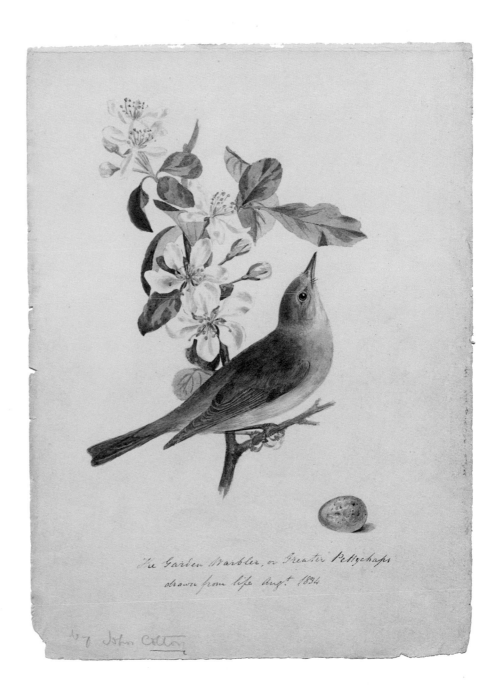

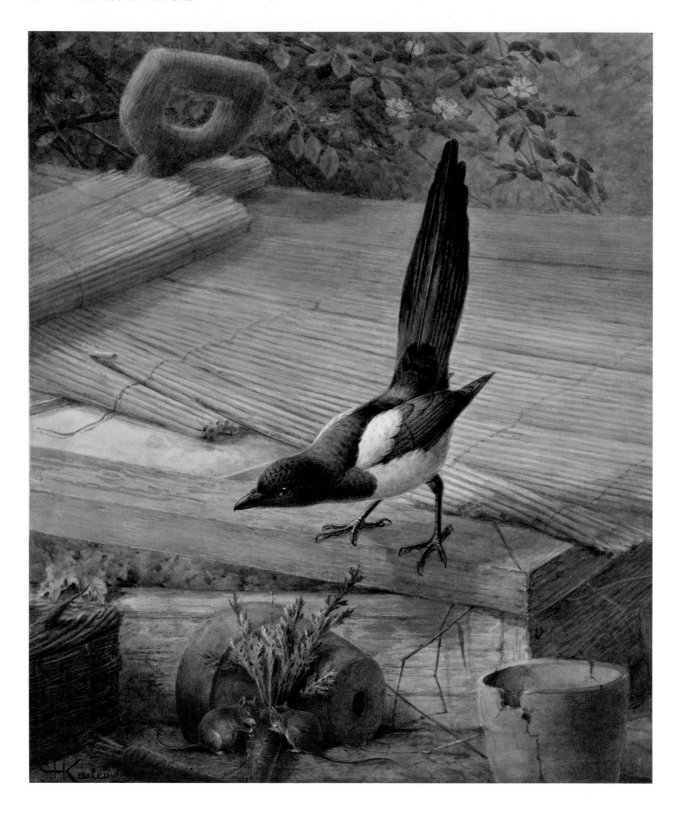

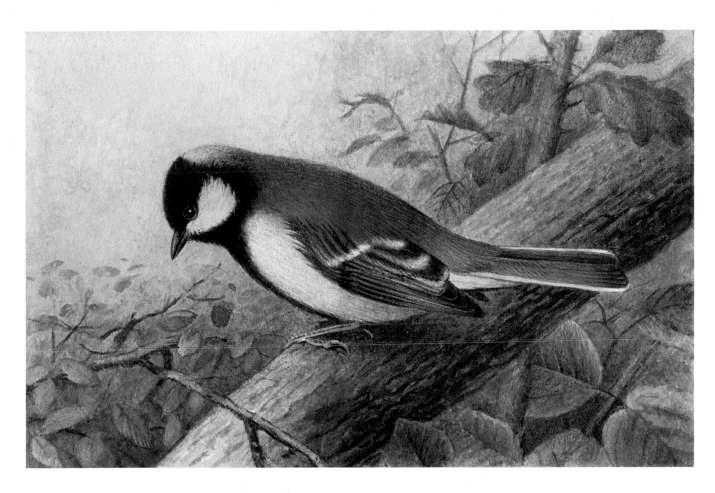

Pica pica, common magpie

Dutch artist Keulemans was one of the most prolific bird artists of his day. In 1869 he moved to England where he remained for the rest of his life. Keulemans' ability to create scientifically accurate and attractive illustrations placed him in great demand by patrons who included Lord Rothschild, whose collection this striking depiction of a magpie is from.

John Gerrard Keulemans (1842–1912)
Watercolour on paper
1896/7
632 x 523 mm

Parus major, great tit

The great tit is one of the commonest and largest tits and has a very recognisable 'teacher teacher' call. In Europe a total of up to 40 different vocalisations have been recorded and a typical male may regularly use a 'vocabulary' of 22 such sounds. Gronvold was a Danish naturalist and artist best known for his illustrations of birds. After arriving in England in 1892, he worked for a few years at the Natural History Museum where he became a skilled taxidermist and established his reputation as a bird artist.

Henrik Gronvold (1858–1940)
Watercolour on card
c. 1926
119 x 164 mm

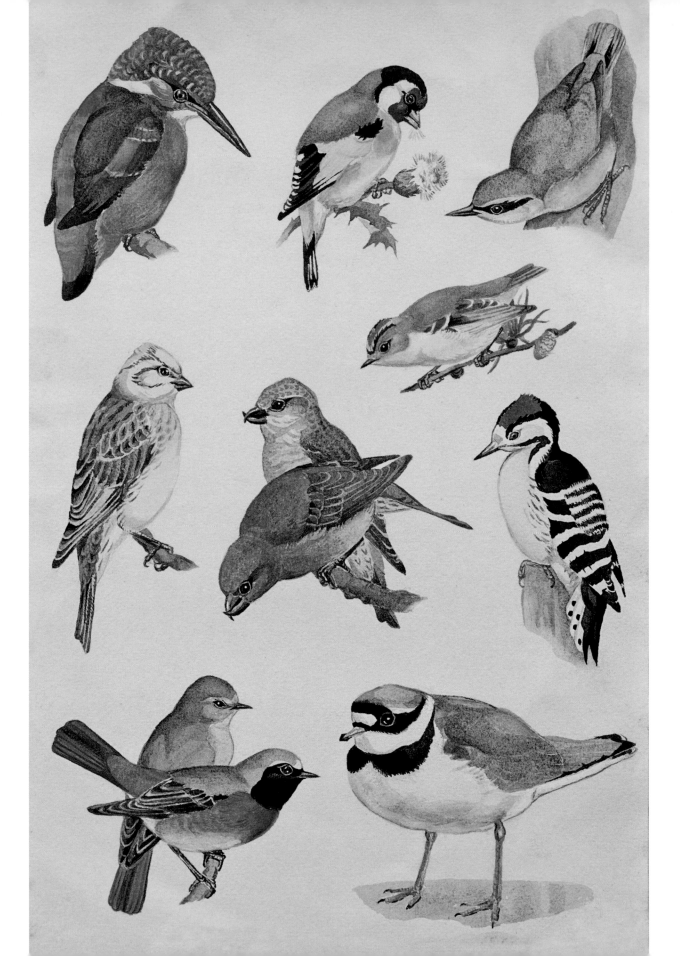

From left to right, top to bottom:
Alcedo atthis; *Carduelis carduelis*;
Sitta europaea; *Regulus regulus*;
Emberiza citrinella; *Loxia curvirostra*;
Dendrocopos minor; *Phoenicurus
phoenicurus*; *Charadrius hiaticula*,
common kingfisher; goldfinch; Eurasian
nuthatch; goldcrest; yellowhammer;
common crossbill; lesser spotted
woodpecker; common redstart;
common ringed plover

Lumsden's illustrations were published in
James Macdonald's *Birds of Britain* (1949).
This illustration was the first plate in the
book, which also provided a selected list of
the various weights of birds – the kingfisher
is given as weighing 1–1¼ oz (35 g).

Phyllida Lumsden (active 1946–1952)
Watercolour on paper
c. 1940s
369 x 244 mm

From left to right, top to bottom:
Asio otus; *Tyto alba*; *Asio flammeus*;
Athene noctua; *Strix aluco*, long-eared
owl; barn owl; short-eared owl; little owl;
tawny owl

The illustration shows the five species of
British owls, although in recent years the
snowy owl and European eagle owl have
also been sighted in southern England and
Yorkshire, respectively. The tawny owl is the
most common British owl with an estimated
50,000 breeding pairs. Its call is the familiar
'too-whit-too-who'.

Phyllida Lumsden (active 1946–1952)
Watercolour on paper
c. 1940s
282 x 185 mm

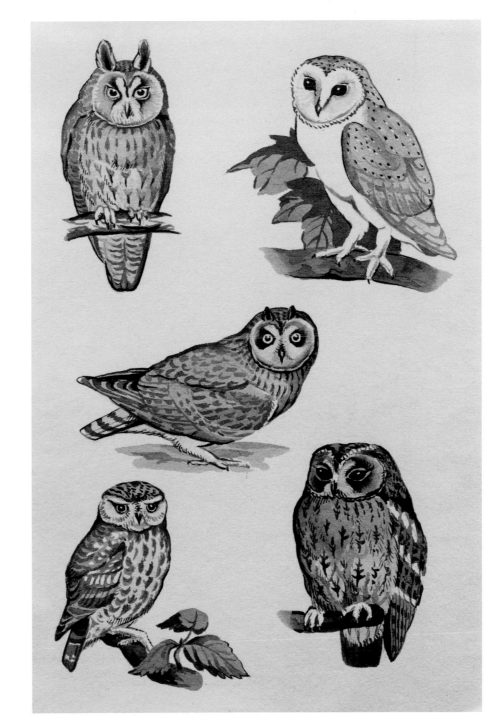

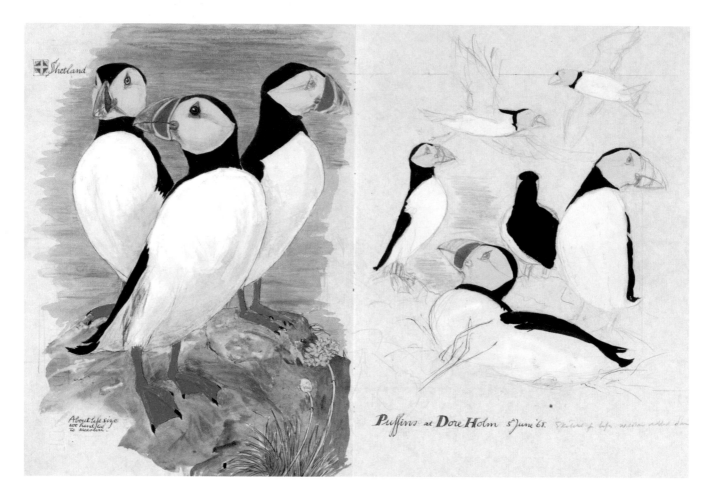

Fratercula arctica, puffin

New Zealand-born Dawson moved to the Shetland Islands in the late 1950s where she sketched and painted birds, mammals and landscapes. This illustration accentuates the unmistakable features of the puffin, a bird that spends most of its life out at sea – a black and white plumage, brightly-coloured bill and vivid orange legs.

Muriel Helen Dawson (1897–1974)
Watercolour and pen on paper
1968
362 x 260 mm

Phalacrocorax carbo, great cormorant

Cusa lived on the Norfolk coast, which is regarded as one of the best counties for birdwatching, regardless of the season. Cormorants are efficient predators of fish and because of a substantial increase in numbers since the 1970s, and their migration inland, they have become unpopular with anglers and fisheries and are often blamed for depleting fish stocks.

Noel William Cusa (1909–1990)
Watercolour on paper
1973
269 x 190 mm

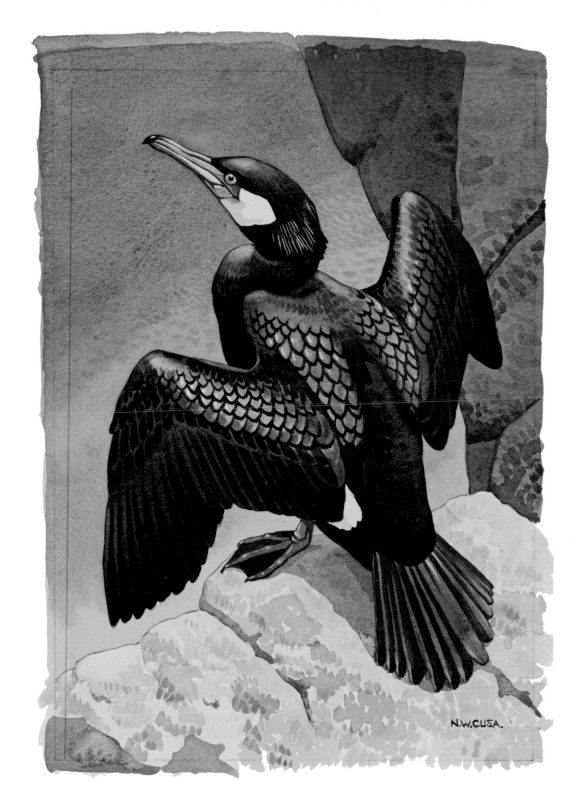

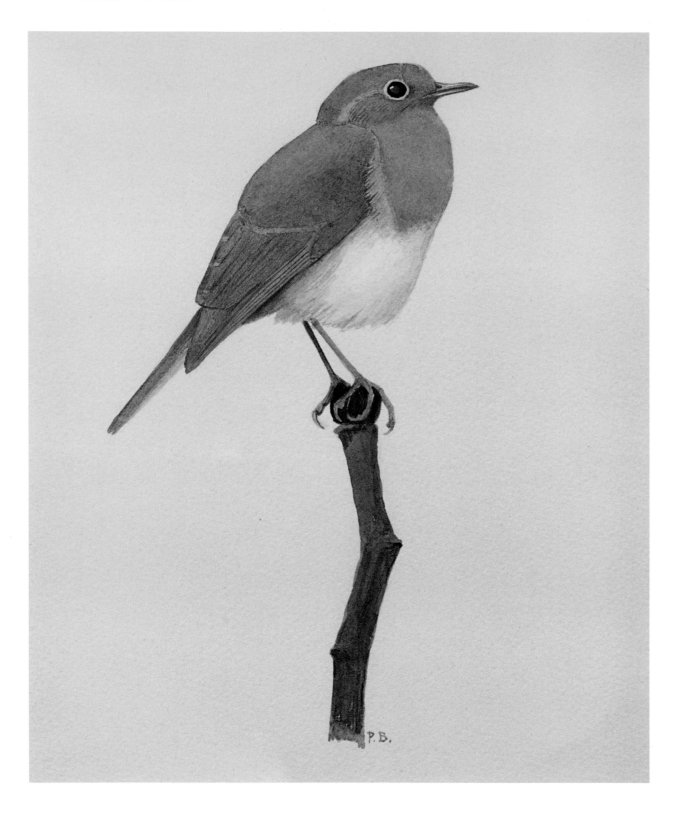

Erithacus rubecula, European robin

The robin is one of the UK's most popular garden birds. It is an insectivorous species, which is why it is so often found by gardeners as it looks for worms and other food. Its distinctive red-orange 'breast' is not present at birth but appears two to three months after it leaves the nest. The Natural History Museum only holds two examples of this French artist's work.

Paul Barruel (1901–1982)
Watercolour on paper
c. 1970s
221 x 146 mm

Phylloscopus trochilus, willow warblers

In 1973, the Natural History Museum commissioned some of the best British zoological artists of the time to illustrate a collection of 50 paintings of British Birds. Harle contributed three illustrations to this collection including this painting of willow warblers – migratory birds whose populations in England have decreased dramatically in the past 25 years.

Dennis F. Harle (1920–2001)
Watercolour on paper
1973
262 x 185 mm

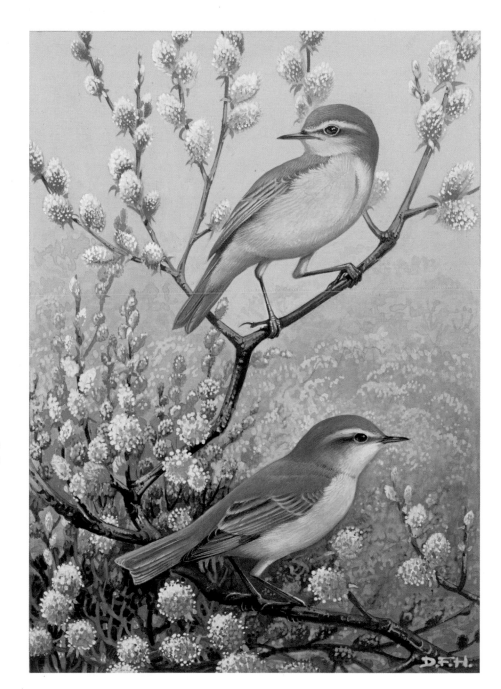

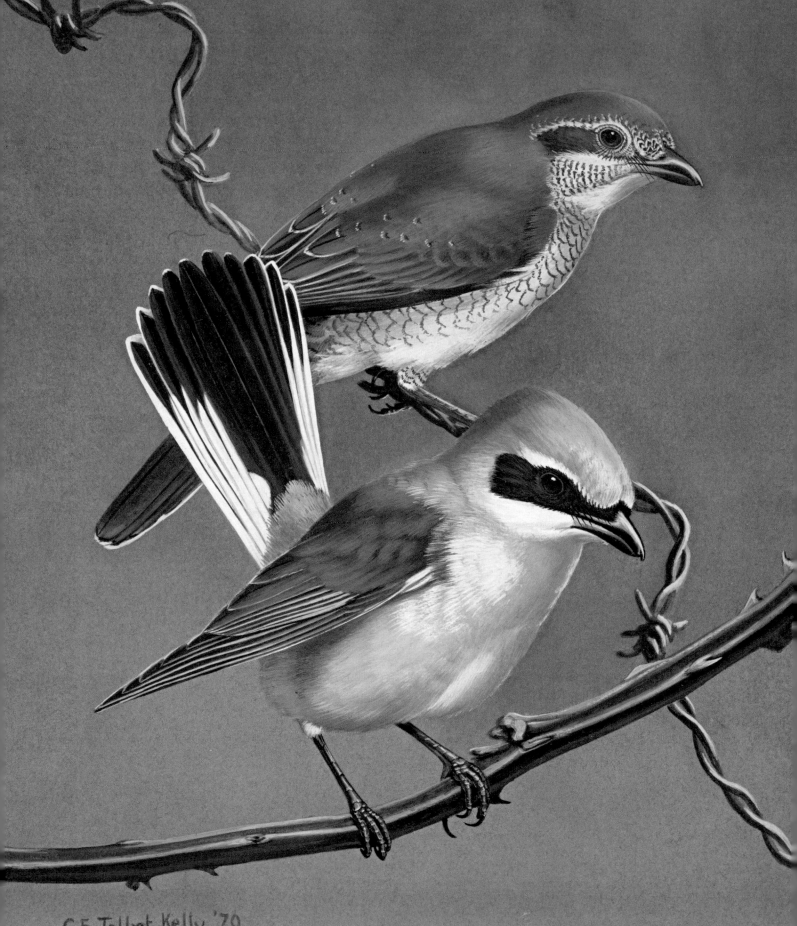

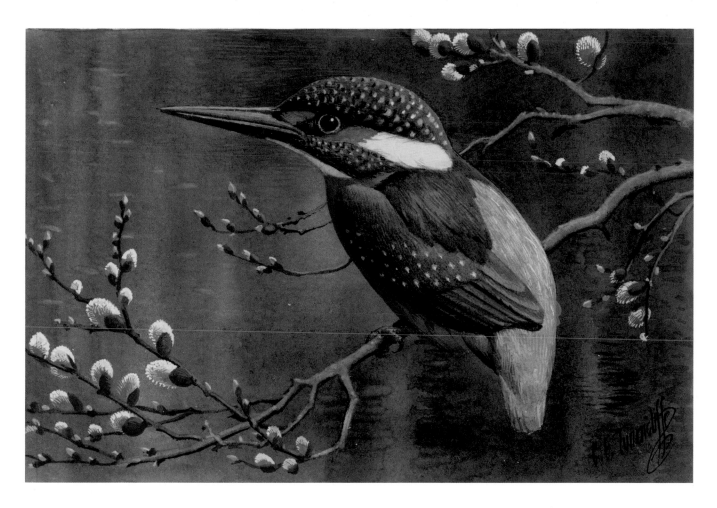

Lanius collurio, red-backed shrike

Male red-backed shrikes have bluish-grey heads with a broad black 'bandit mask' through their eyes. Known as the 'butcher bird' it impales its prey on thorn bushes. Common in other parts of the world, in the British Isles their numbers have declined so dramatically in the past century that the species is practically extinct as a breeding bird.

Chloe E. Talbot Kelly (b.1927)
Watercolour on paper
1973
243 x 179 mm

Alcedo atthis, common kingfisher

The common kingfisher flies incredibly fast creating the effect of a blue flash due to the eye-catching iridescent blue plumage down its back. A widely distributed but territorial bird, it lays glossy white eggs and its presence is considered an indicator of a healthy ecosystem.

Charles Frederick Tunnicliffe (1901–1979)
Watercolour on paper
1973
243 x 179 mm

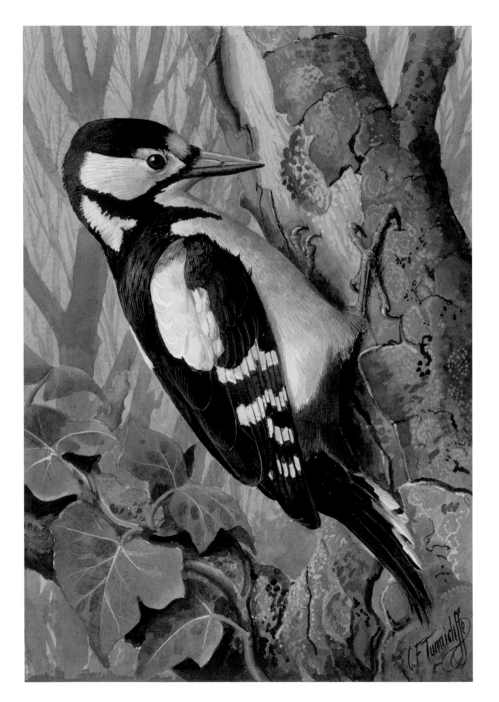

Dendrocopos major, great spotted woodpecker

The name of the great spotted woodpecker comes from the Greek words 'dendron' meaning tree and 'kopos' meaning striking. Woodpeckers use their beaks to drill holes into tree trunks – this process creates the drumming sound that they are affectionately renowned for. They have long sticky tongues that they poke into the holes to retrieve insects.

Charles Frederick Tunnicliffe (1901–1979)
Watercolour on paper
1973
380 x 266 mm

Micromys minutus, harvest mouse

With a tail almost as long as its body, the pretty harvest mouse
is one of Britain's smallest mammals and was first identified as
a separate species in 1767 by the pioneering British naturalist
Gilbert White (1720–1793). Their broad paws not only help them
climb corn stalks but also enable them to build their wonderfully
woven and much admired nests of grasses or reeds.

James Hope Stewart (1789–1883)
Watercolour on paper
c. 1830s
120 x 176 mm

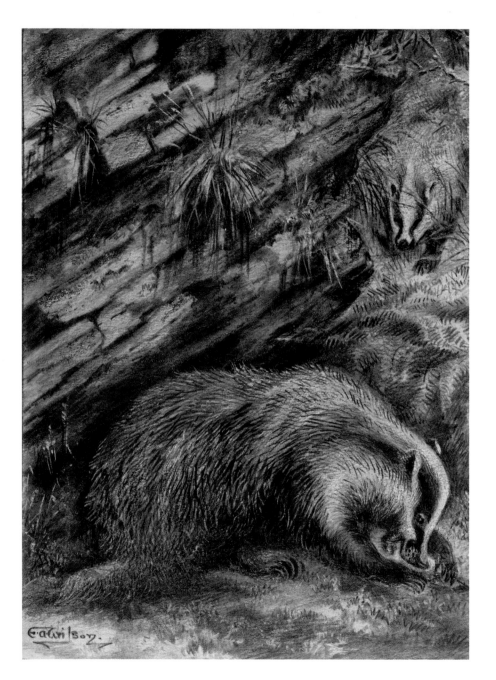

Meles meles, European badger

Badgers are widespread in Britain, though more are found in the wetter areas of the south and southwest, but due to their nocturnal habits and winter torpor they are very rarely seen. They are protected under the Protection of Badgers Act 1992, which makes it an offence to kill a badger or destroy a badger sett.

Edward Wilson (1872–1912)
Watercolour on paper
1905–1910
229 x 165 mm

Cervus elaphus, red deer

The red deer is the largest surviving indigenous land mammal in the British Isles, having migrated to Britain from Europe 11,000 years ago. A male stag can stand at 1.2 m (4 ft) in height at the shoulders. Red deer are most commonly found in Scotland, particularly the Highlands, as well as the north-west and south-west of England. Other scattered populations also exist across England, Wales and Northern Ireland.

Edward Wilson (1872–1912)
Watercolour on paper
1905–1910
274 x 194 mm

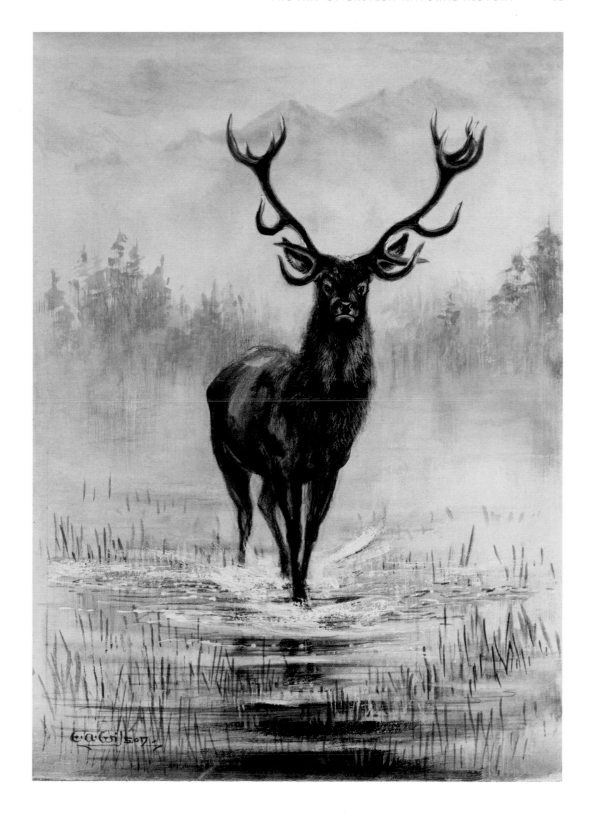

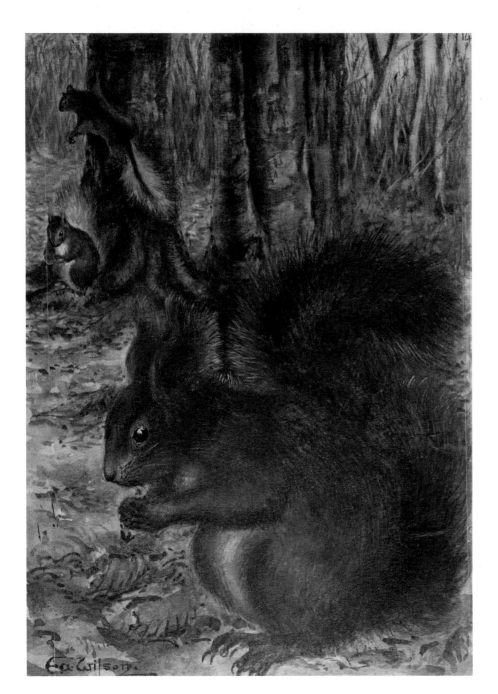

Sciurus vulgaris, Eurasian red squirrel

The red squirrel is native to Britain and is one of our most picturesque but elusive small mammals. Their populations have seen a dramatic decline due to habitat destruction and the introduction of the American grey squirrel in 1876, a larger and more robust species, which also carries a virus that the red squirrel has little immunity to.

Edward Wilson (1872–1912)
Watercolour on paper
1905–1910
225 x 159 mm

Muscardinus avellanarius, hazel dormouse

The hazel dormouse is the only species of dormouse native to the British Isles. Wilson completed his illustrations of British mammals and birds between 1905 and 1910, prior to returning to the Antarctic on the fateful *Terra Nova* expedition where he died along with Captain Scott on their return to base after successfully reaching the South Pole in 1912.

Edward Wilson (1872–1912)
Watercolour on paper
1905–1910
276 x 194 mm

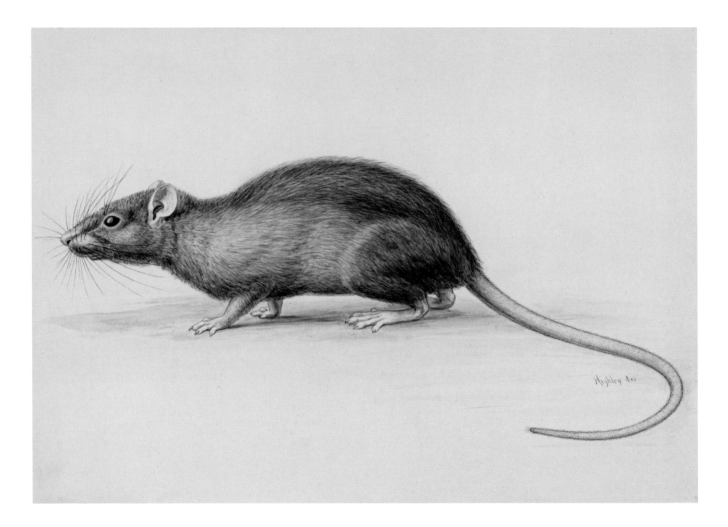

Rattus rattus, roof rat

Excellent climbers, roof rats are one of the most highly adaptable
of the British mammals. Regarded as carriers of disease and
general pests, they are prodigious breeders. First described in the
eighteenth century by the Swedish naturalist Carl Linnaeus, this
rodent has retained its original tautonym (the same word being
used for both genus and species in a scientific name), indicating
that it is the type species of the genus.

Percy Highley (1856–1929)
Ink and graphite on card
c. 1918
266 x 372 mm

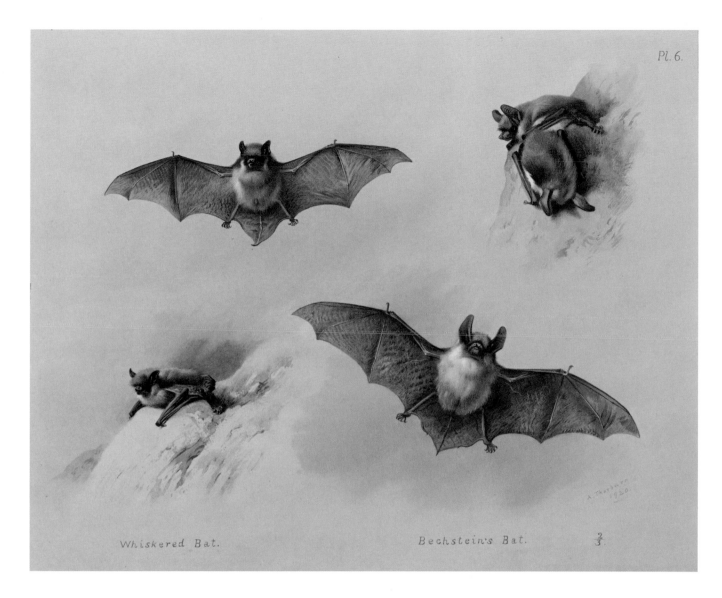

Pl. 6.

Whiskered Bat.

Bechstein's Bat.

⅔

Myotis bechsteinii, Bechstein's myotis

There are 18 species of bat found in Britain, of which Bechstein's myotis is the rarest. Its population has been affected by the destruction of ancient woodlands. It is therefore a UK Biodiversity Action Plan priority species, requiring conservation action, in addition to being protected under the European Habitats Directive.

Archibald Thorburn (1860–1935)
Watercolour on paper
1920
425 x 594 mm

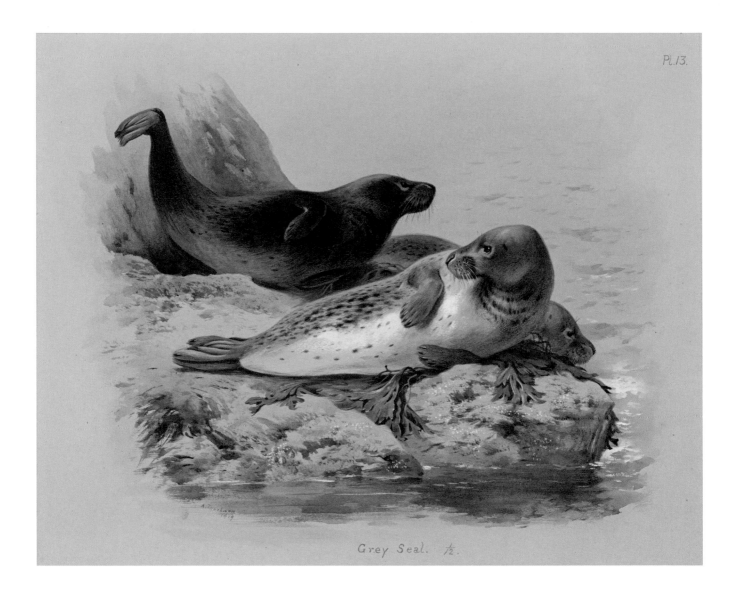

Grey Seal. ½.

Halichoerus grypus, grey seal

Grey seals are found mainly along exposed rocky northern and western coasts of the British Isles. They spend around two-thirds of their time at sea, where they hunt and feed mainly for fish and crustaceans. They can live for up to 35 years. Thorburn was a Scottish artist who painted mostly in watercolour and is noted for the picturesque and dramatic backgrounds he placed his natural history subjects in.

Archibald Thorburn (1860–1935)
Watercolour on paper
1919
424 x 551 mm

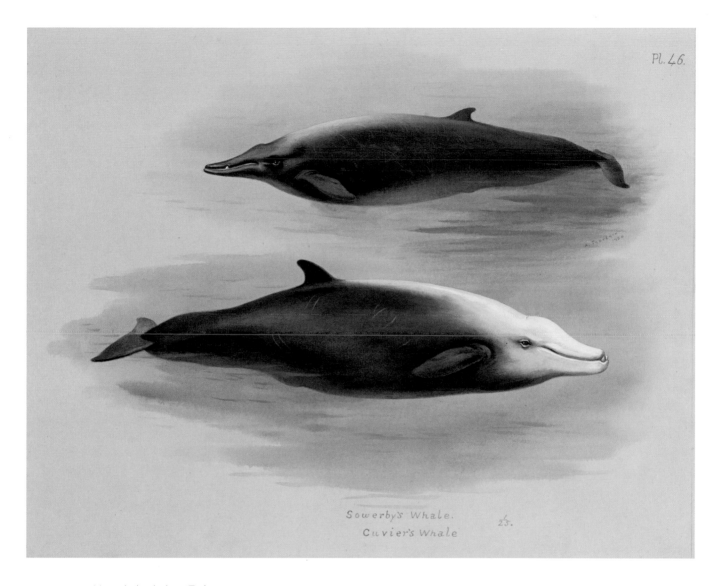

Top to bottom: *Mesoplodon bidens*; *Ziphius cavirostris*,
Sowerby's beaked whale; Cuvier's beaked whale

There are 22 species of beaked whales in the Ziphiidae family,
known for their ability to dive to great depths to hunt squid, fish
and crustaceans. Cuvier's beaked whale holds the record for both
the longest duration and deepest dive of any mammal.

Archibald Thorburn (1860–1935)
Watercolour on paper
1920
390 x 548 mm

Oryctolagus cuniculus, European rabbit

Rabbits were first brought to England in the twelfth century AD by the Normans, and despite the disease myxomatosis being introduced in the 1950s to control wild populations, they remain a common sight as they have gradually become immune to the virus. Lodge was best known and loved as a bird artist but he was also a skilled taxidermist, keen falconer and engraver of wood cuts. An active conservationist, Lodge was on the board of the Society for the Promotion of Nature Reserves and various bird societies.

George Edward Lodge (1860–1954)
Watercolour on paper
c. 1820s
219 x 280 mm

Martes martes, European pine marten

The pine marten's range is predominantly restricted to Scotland. Its bushy tail helps it balance upon branches as it pursues birds or attempts to steal eggs from their nests. Pine martens and their dens are protected under the Wildlife and Countryside Act 1981 and the Environmental Protection Act 1990.

Miss F. R. Mold (fl.1924–1925)
Watercolour on paper
1925
204 x 133 mm

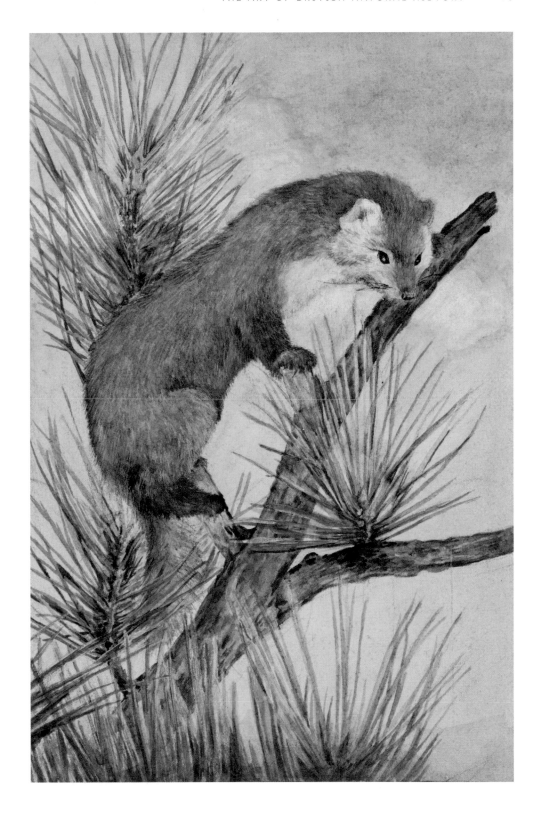

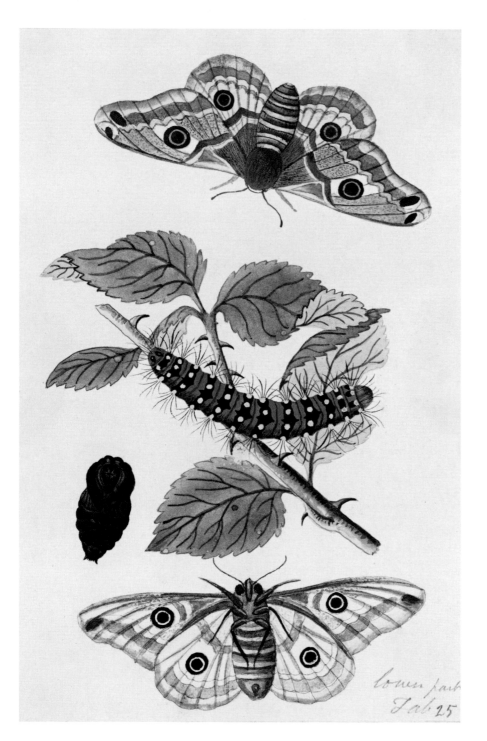

Saturnia pavonia, emperor moth

The emperor moth is Britain's only resident moth of the Saturniidae family. When hatched, the caterpillars feed mainly on heather and are black and orange but when fully grown they turn green with black stripes and bristles. Albin was both a naturalist and a skilled artist who prided himself on drawing from life and his visual accuracy.

Eleazar Albin (fl.1690–c.1742)
Watercolour on paper
c. 1712
187 x 121 mm

Includes: a–d. *Callophrys rubi*, green hairstreak; p. *Diacrisia sannio*, clouded buff; k–o. *Hydrochara caraboides*, lesser silver water beetle; top left and top right: *Argynnis aglaja*, dark green fritillary

In 1758 Harris started work on his major and celebrated work on butterflies and moths. *The Aurelian; or Natural History of English Insects*. Completed in 1766, it is regarded as one of the most outstanding entomological works of the eighteenth century. Harris drew his specimens from life and it is thought he reared many of them himself in order to show their various stages of development.

Moses Harris (1730–1788)
Watercolour and bodycolour on paper
c. 1780s
310 x 240 mm

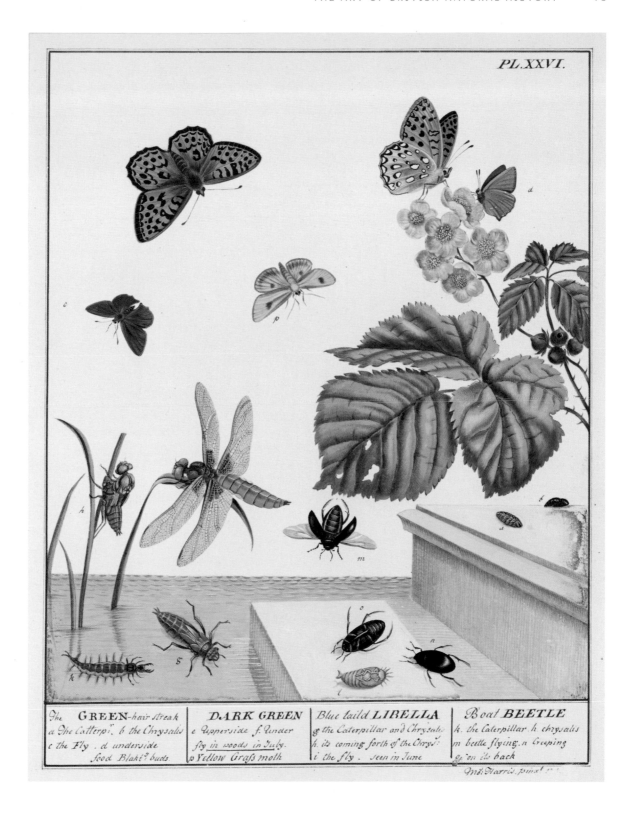

PL.XXVI.

The **GREEN**-hair streak
a The Catterpi: b the Chrysalis
c the Fly . d underside
food Blakb: buds.

DARK GREEN
e Upperside f. Under
fly in woods in July.
p Yellow Grass moth

Blue taild **LIBELLA**
g the Caterpillar and Chrysalis
h. its coming forth of the Chrys:
i the fly . seen in June

Boat **BEETLE**
k. the Caterpillar h chrysalis
m beetle flying. n Creeping
g: on its back

Mr. Harris pinxt:

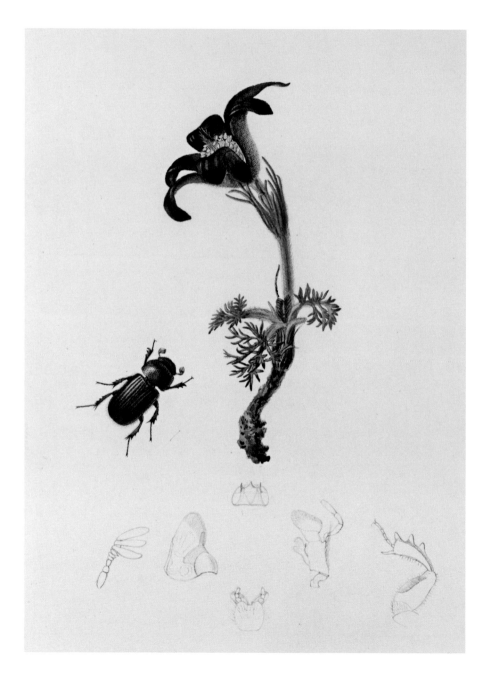

Euheptaulacus villosus, hairy dung beetle on *Pulsatilla vulgaris*, pasqueflower

This illustration was published in Curtis's *British Entomology*, for which Curtis not only illustrated but engraved the 770 plates that were published in parts between 1823 and 1839. It was his intention to illustrate the most rare and beautiful species of insects together with the plants on which they are found. The hairy dung beetle has been paired with the pasqueflower in this illustration as they both like well-drained, chalky, calcareous soil.

John Curtis (1791–1862)
Watercolour on paper
c. early 1820s
242 x 150 mm

Vanessa cardui, painted lady

This butterfly is a migrant to the British Isles, leaving North Africa, the Mediterranean and central Asia and arriving in the British Isles late summer. Common and widespread once it arrives, it is not a resident species as it is unable to survive British winters.

John Emmerson Robson (1833–1907)
Watercolour on card
c. 1890s
205 x 167 mm

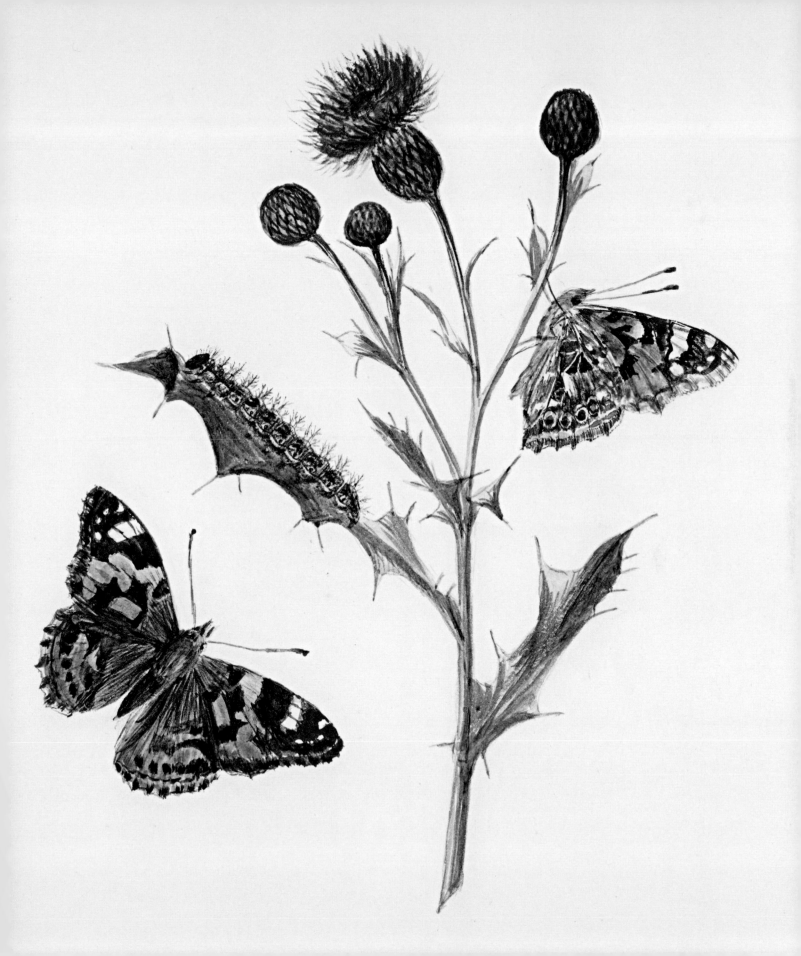

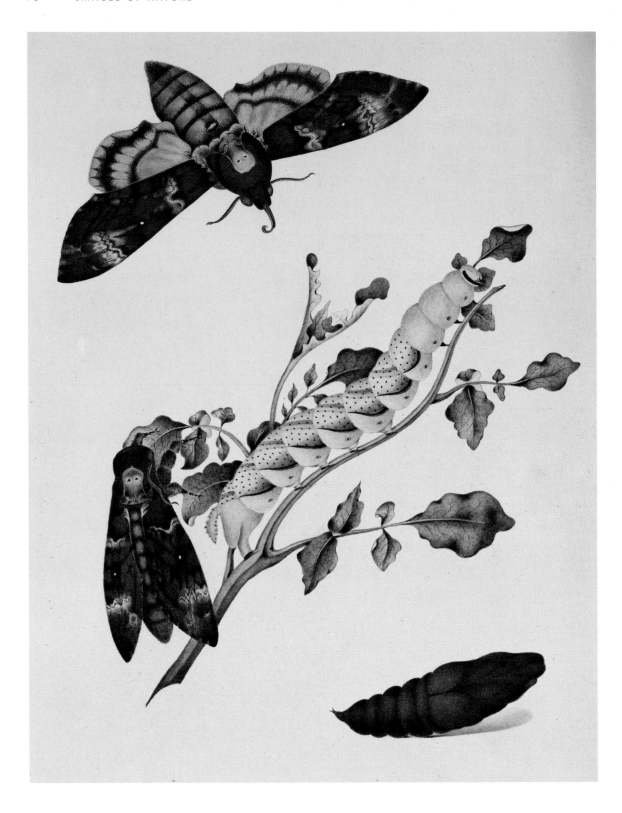

Acherontia atropos, death's-head hawkmoth

Most of the moths found in the British Isles are resident species but there has been an increase in recent years of migrant moths from the continent due to warmer weather. The death's-head hawkmoth is not a native moth but migrates annually from southern Europe. One of the larger moth species, its wing span can grow up to 12 cm (5 in) and it will emit a 'squeak' if disturbed. It gets its common name from the skull-like pattern found on its thorax.

Francis Oram Standish (1832–1880)
Watercolour on paper
c. mid-nineteenth century
302 x 228 mm

Nothridae

Oribatid mites are a type of soil mite commonly found in wooded areas where they break down organic matter. The size of a pinhead, they range in size from 0.2 to 1.4 mm. There are over 300 oribatid mites in the fauna of the British Isles, however, a quarter of these are either single records or have not been re-collected in the last 50 years. This original illustration is from Michael's classic work on *British Oribatidae* (1884–1888).

Albert Davidson Michael (1836–1927)
1887
Ink and watercolour on paper
253 x 170 mm

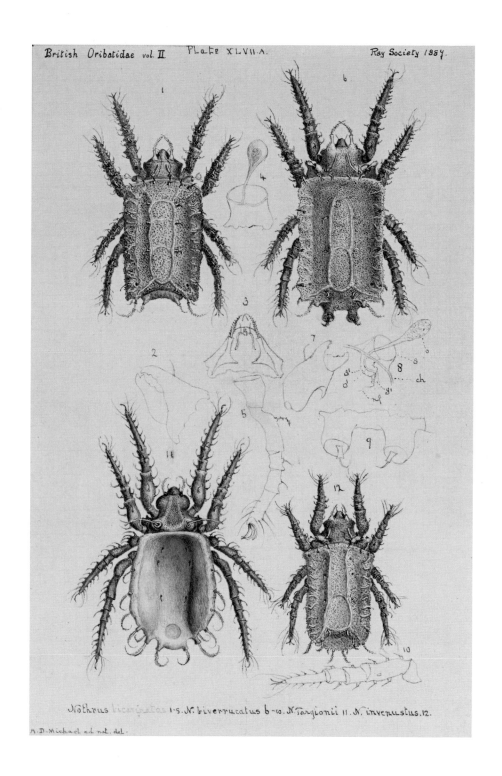

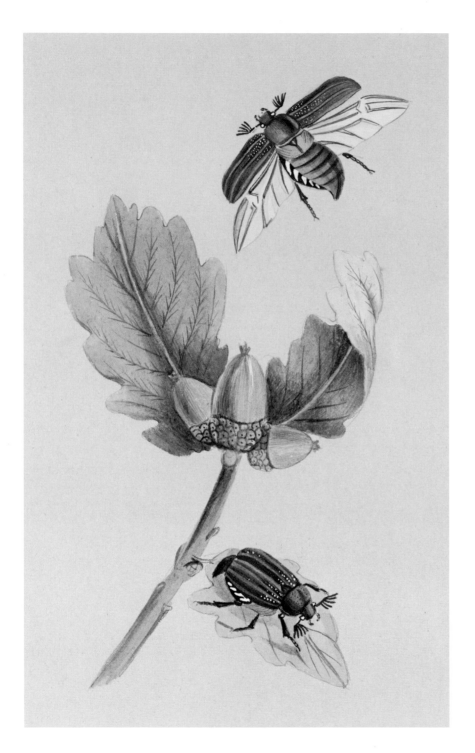

Melolontha melolontha, cockchafer

Male cockchafers can be easily distinguished from females due to the seven 'leaves' found on their antler-like antennae compared to a female's six – inaccurately detailed in this illustration. Their antennae are also longer, helping them detect the pheromones given off by the females at mating time. Frequently found on agricultural land, the larvae of the cockchafer are voracious feeders and can cause significant damage to crops.

Theophilus Johnson (1836–1919)
Watercolour on paper
c. late nineteenth century
250 x 178 mm

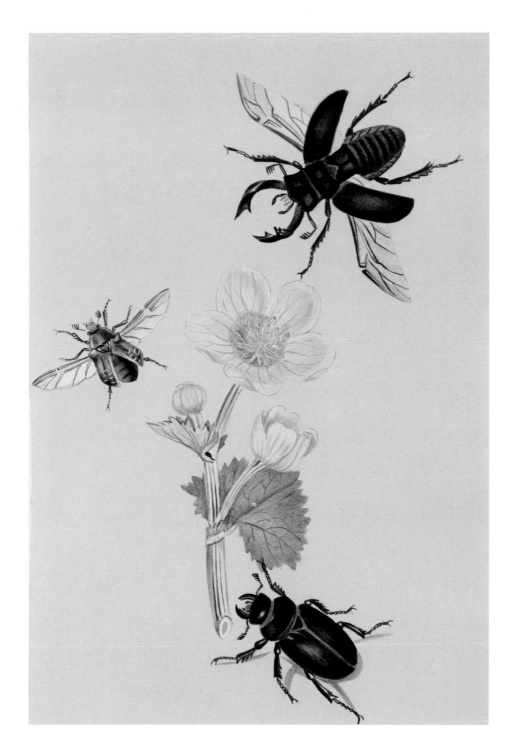

Left: *Cetonia aurata*, rose chafer;
top and bottom: *Lucanus cervus*, stag
beetle

The rose chafer is a large, bright metallic-
green beetle common in southern
England. The stag beetle, however, is
the largest British beetle with the male
stag growing up to 11 cm (4 in) long.
Both beetles can share the same habitat,
compost heaps or decaying wood, but it is
not always easy to tell their larvae apart.

Theophilus Johnson (1836–1919)
Watercolour on paper
c. late nineteenth century
250 x 178 mm

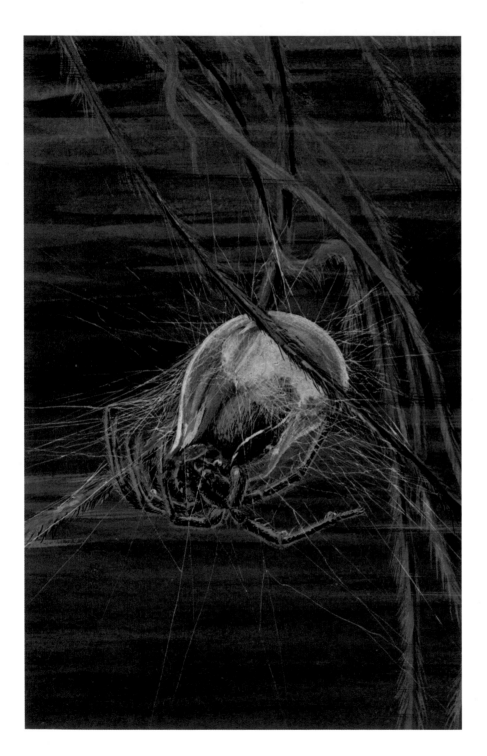

Argyroneta aquatica, diving bell spider
or water spider

This spider lives predominantly underwater
and is able to breathe due to the silk-based
structure, which resembles a diving bell, that
it spins among underwater vegetation. The
spider then pokes its rear end above the water
and once it submerges itself again it collects
an air bubble that gets trapped by hydrophobic
(water repelling) hairs on the spider's abdomen
and legs. This is then stored in its bell and acts
like a lung.

Frank Hinkins (1852–1934)
Watercolour on card
c. 1900–1920s
190 x 132 mm

Arrenurus scourfieldi, water mite

This illustration is from a plate that was
published in *The Journal of the Quekett
Microscopical Club* in 1913, accompanied
by the text describing it as a new species of
water mite. Soar named it after David Joseph
Scourfield (1866–1949), an amateur biologist
and microscopist, who had collected it in
Cornwall. A close relative of the spider the
water mite has eight legs and a soft body.

Charles David Soar (1853–1939)
Ink and wash on card
1913
100 x 100 mm

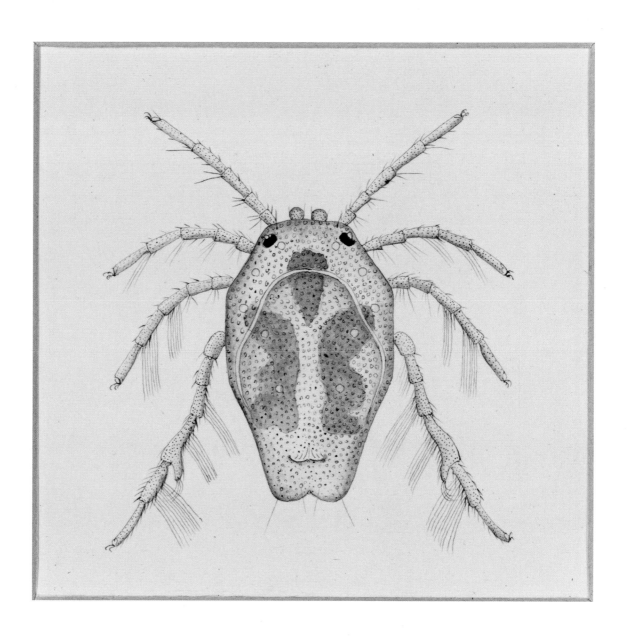

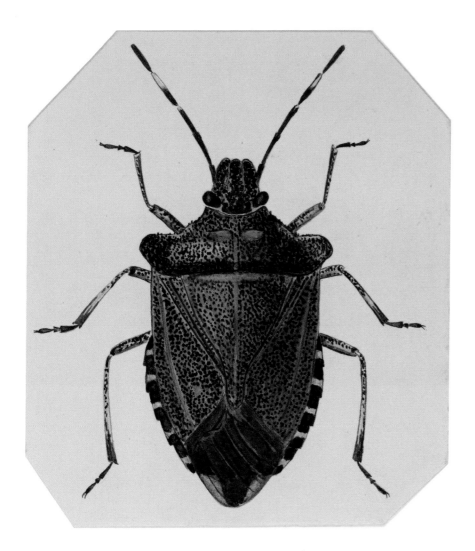

Troilus luridus, bronze shieldbug

This illustration was originally published in Southwood and Leston's *Land and Water Bugs of the British Isles* (1959). *Troilus luridus* is one of the carnivorous species of shieldbugs and occurs widely across Britain and Ireland. They are named due to their heraldic shield-like shape.

Humphrey Drummond Swain (1902–1959)
Watercolour on card
c. 1950s
103 x 89 mm

Top to bottom: *Pholidoptera griseoaptera*, dark bush-cricket, adult male; *Pholidoptera griseoaptera*, dark bush-cricket, adult female; *Platycleis albopunctata albopunctata*, grey bush-cricket, adult male; *Platycleis albopunctata albopunctata*, grey bush-cricket, adult female

Both of these cricket species belong to the family Tettigoniidae and are native to the British Isles. The grey bush-cricket is considered scarce and is a strictly coastal species whereas the dark bush-cricket is more common, but is almost wingless, and so, unlike the grey bush-cricket, cannot fly.

Humphrey Drummond Swain (1902–1959)
Watercolour on card
c. 1950s
332 x 215 mm

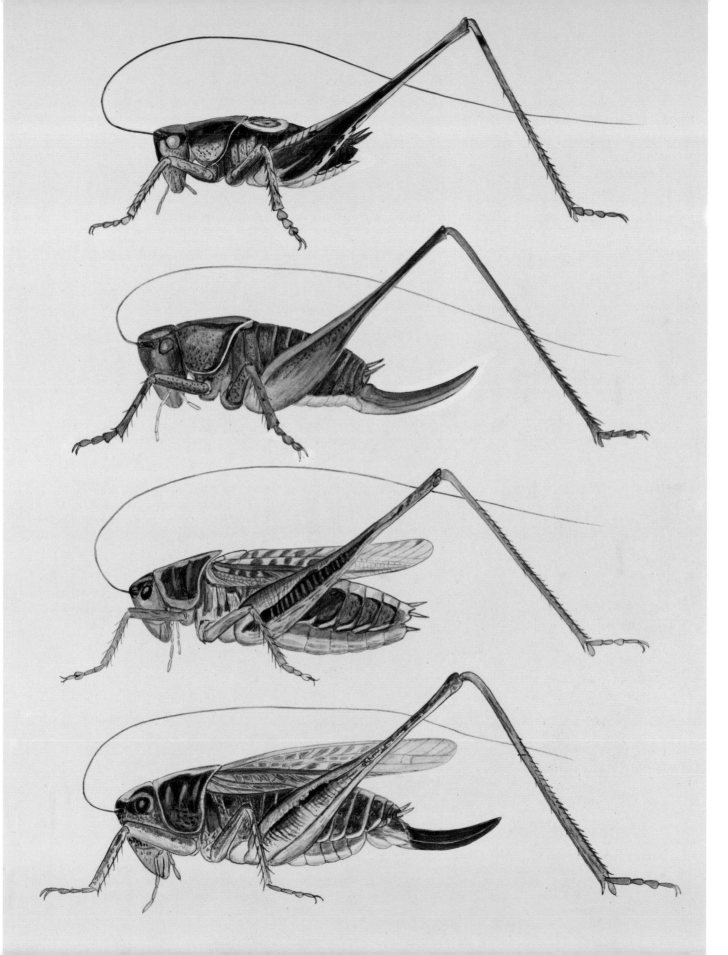

Bottom centre: *Cydia ulicetana*, seed pod of *Ulex europaeus* containing a larva; left and far right: *Cydia servillana*, stems of *Salix*, with gall-like swellings caused by larva; top centre: *Cydia nigricana*, pod of cultivated pea (*Pisum sativum*) containing a larva

This illustration by Smith shows the larvae of different species of *Cydia* moths in the family Tortricidae. It shows the larva in the plants on which they feed and for *Cydia servillana* indicates the swelling or gall caused by the larva once they hatch and tunnel into the tissue of their host.

Arthur Clayton Smith (1916–1991)
Graphite and ink on paper
c. early 1970s
Various sizes

Eresus sandaliatus, ladybird spider

The ladybird spider gets it common name from the colouration found on the mature male spider as the female ladybird spider and male juveniles are completely black. Thought to be extinct in Britain, it was rediscovered in 1980 and despite ongoing efforts to increase its populations it remains incredibly rare. It is classified as endangered in the *British Red Data Book*.

Michael Roberts (b.1945)
Ink on card
1978
265 x 183 mm

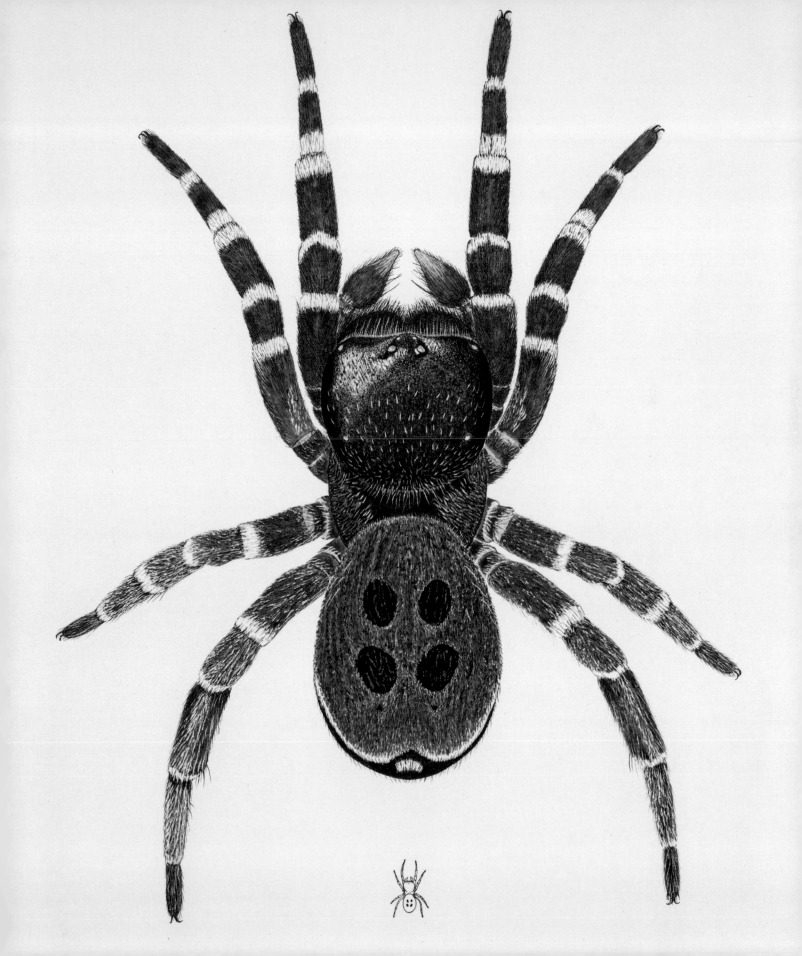

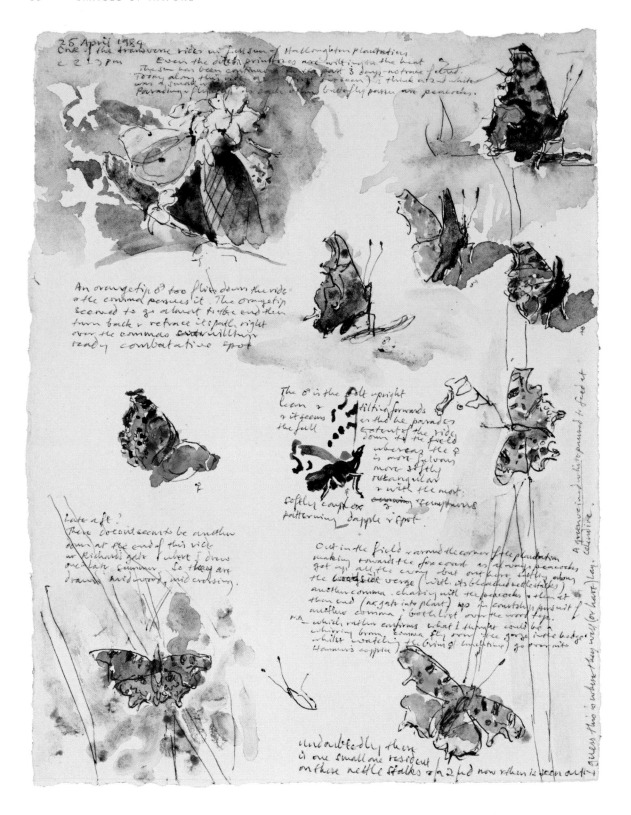

Gonepteryx rhamni and *Polygonia c-album*, brimstone and comma

Measures is regarded as one of the first artists to illustrate butterflies in flight in their natural habitats. His fascination with butterflies and his artistic training enabled him to develop a remarkable skill in capturing such moments in a free and fluid style, which he accompanied with detailed notes and observations, each sheet being dated and timed. His work was eventually published in 1996 titled *Butterfly Season: 1984*.

David Measures (1937–2011)
Watercolour and ink on paper
1984
277 x 210 mm

Top to bottom, left to right: *Acronicta tridens*, dark dagger; *Acronicta psi*, grey dagger; *Acronicta menyanthidis*, light knot grass; *Craniophora ligustri*, coronet; *Acronicta cinerea*, sweet gale; *Acronicta rumicis*, knot grass

Over 2,500 species of moths have been recorded in the British Isles. This collection of illustrations is from a collection of 540 original watercolour drawings of caterpillars of British moths and butterflies, some of which were published in W. J. Stokoe's *Caterpillars of British Butterflies* (1944) and *Caterpillars of British Moths* (1948).

John Charles Dollman (1851–1934)
Watercolour on paper
c. early twentieth century
162 x 118 mm

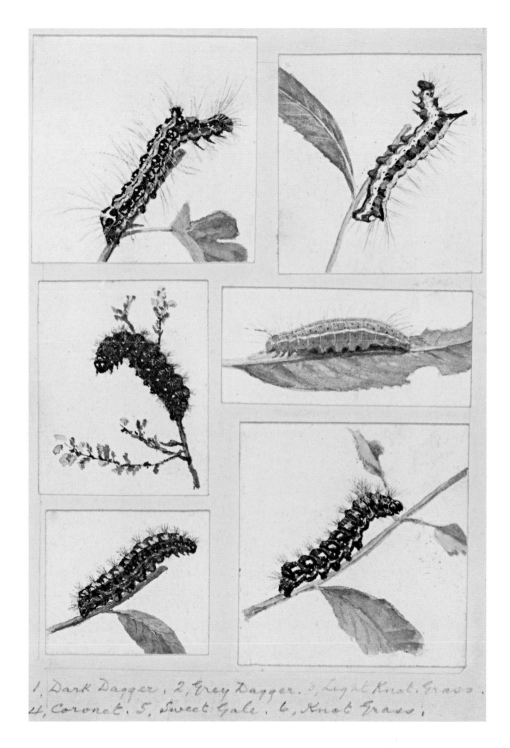

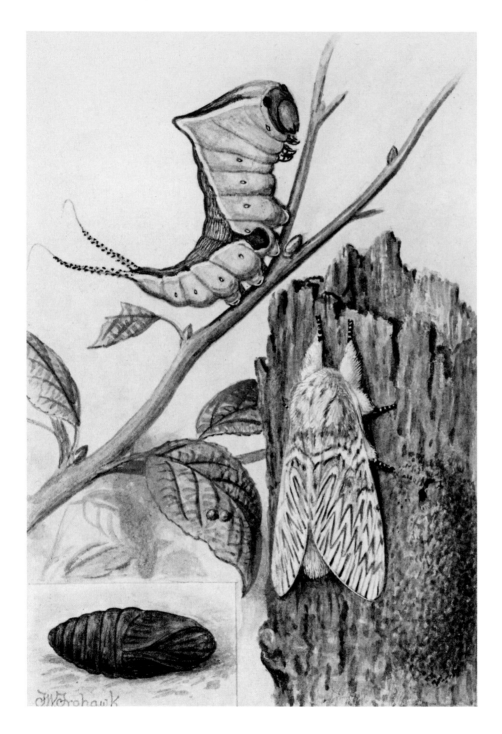

Cerura vinula, puss moth

The puss moth gets its name from the soft cat-like fur that covers its body. The green caterpillar of the moth is also distinctive with a spike protruding from the rear and a red-ringed 'face' at its head. Frohawk illustrated numerous books on birds but his main passion was for butterflies and moths. Encouraged in his illustrations by zoologist Walter Rothschild (1868–1937), it was to Rothschild that Frohawk sold his butterfly collection in 1927 due to financial need. It is now housed at the Natural History Museum.

Frederick William Frohawk (1861–1946)
Watercolour on paper
c. early twentieth century
140 x 89 mm

Euplagia quadripunctaria, Jersey tiger

The distribution of the attractive tiger moth has expanded in recent years from mainly the Channel Islands and the Southwest to more of the southern counties. In the past decade it has also become a common sight in south London. Unlike other moths, the Jersey tiger can be seen during the day, feeding on plants for their nectar.

Frederick William Frohawk (1861–1946)
Watercolour on paper
c. early twentieth century
140 x 89 mm

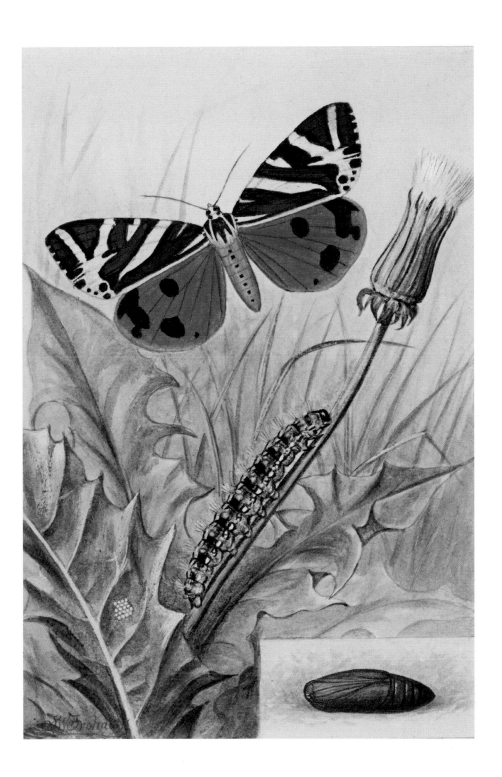

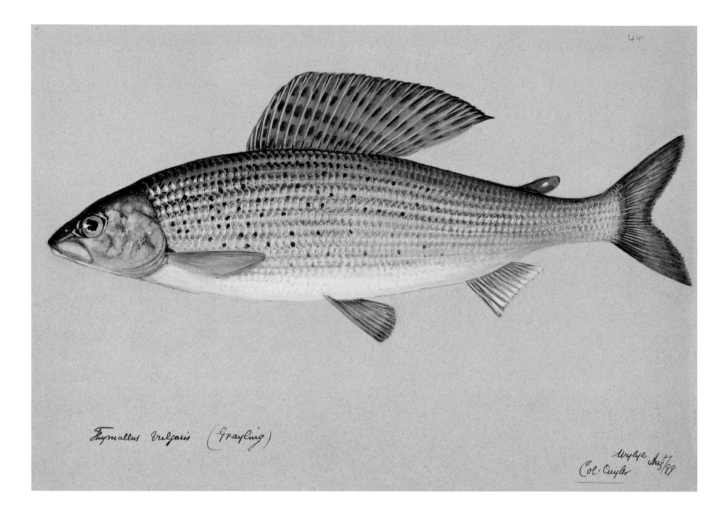

Thymallus thymallus, grayling

Known as the 'lady of the stream', the grayling is widespread in the British Isles and is the only species of the genus *Thymallus* (the graylings) native to Europe. This grayling is from a collection of 127 sheets of watercolour drawings of fishes from British localities that Wheeler carried out between 1897 and 1908.

Edwin Wheeler (1833–1909)
Watercolour on paper
1899
274 x 382 mm

Gasterosteus aculeatus, common stickleback

Also referred to as a three-spined stickleback, these fish can have between two and four spines on their backs. In spring, males develop a bright red throat to attract females. The male then builds a nest for the females to lay their eggs in. Once the eggs are laid the male fans them to give them oxygen and fiercely guards them from predators until they hatch.

S. Hendry (dates unknown)
Watercolour on paper
c. mid-twentieth century?
280 x 280 mm

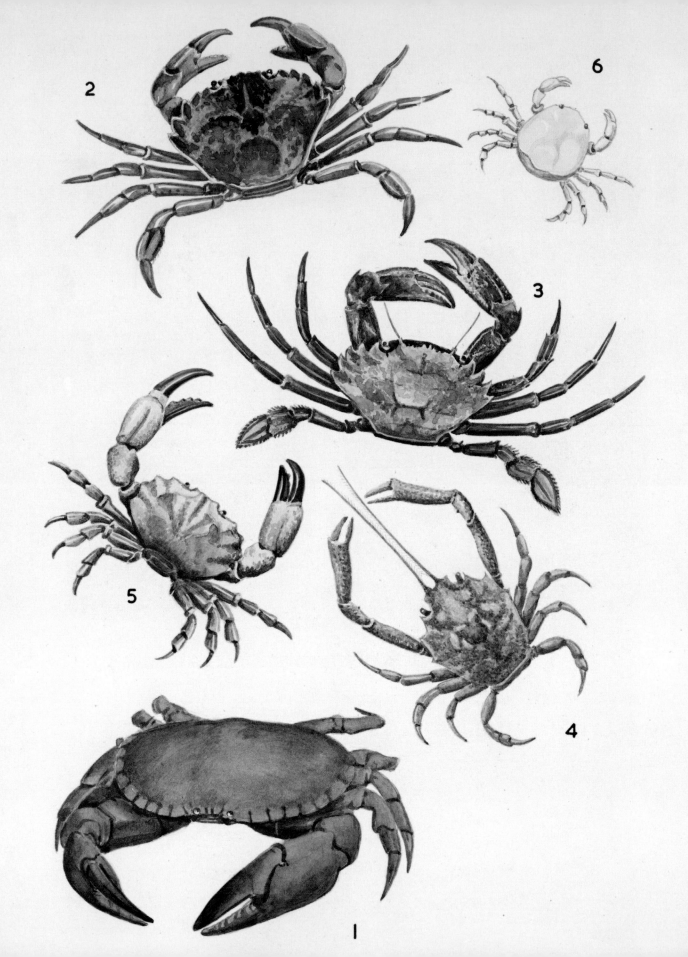

1. *Cancer pagurus*, edible crab;
2. *Carcinus maenas*, shore crab;
3. *Necora puber*, fiddler or velvet swimming crab; 4. *Corystes cassivelaunus*, masked crab or long-clawed crab, sand crab, helmet crab; 5. *Xantho pilipes*, furrowed crab or Risso's crab; 6. *Pinnothere spisum*, pea crab

The pea crab, which is literally the size of a pea, lives as a parasite inside bivalves such as mussels, oysters and clams. The males are active swimmers but the females cannot swim and spend their entire lives inside a host. This illustration was drawn using specimens from the collections at the Natural History Museum and was published in the *Observer's Book of Sea & Seashore* (1962).

Ernest C. Mansell (active 1960s)
Watercolour on paper
c. early 1960s
280 x 192 mm

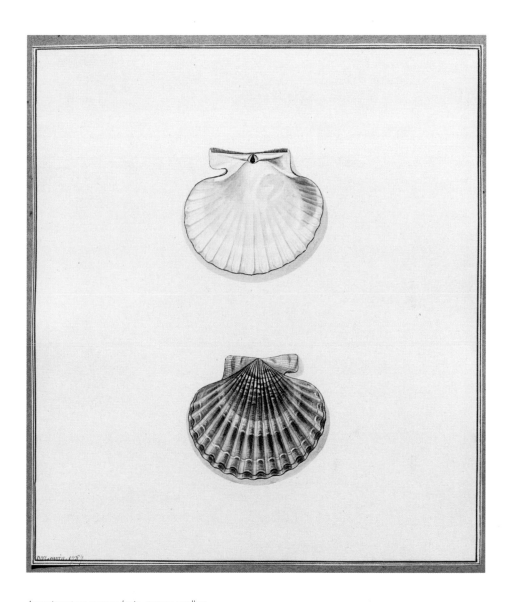

Aequipecten opercularis, queen scallop

The queen scallop is an edible bivalve marine mollusc known locally in the Isle of Man as 'Manx Queenie'. Abundant in the North Sea, they can reach a diameter of 9 cm (3½ in) in size. This illustration is from a collection of 511 watercolour drawings of British land, fresh- and salt-water shells made between 1786 and 1818 by Lewin and J. Agnew.

John William Lewin (1770–1819)
Watercolour on paper
1787
235 x 203 mm

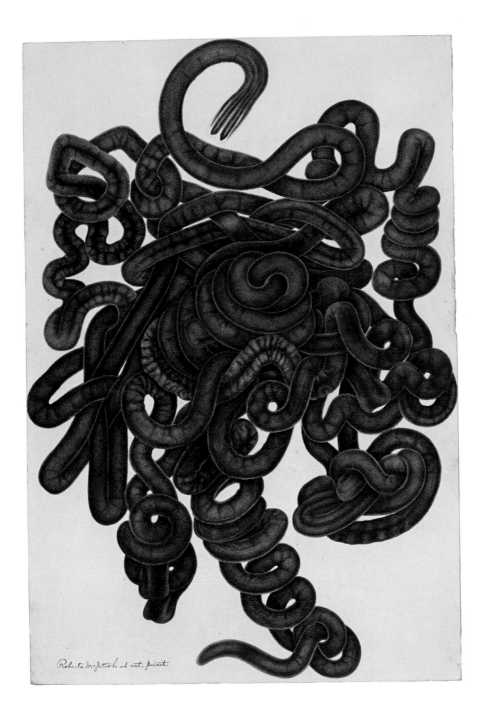

Lineus longissimus, bootlace worm

The bootlace worm is the longest known nemertean (ribbon worm), which as its scientific name implies, is both long and thin with some individuals growing up to 30 m (98 ft) long. The specimen depicted in this illustration was 'even more elongated than the figure indicates' with McIntosh expertly capturing the way it writhes itself in knots.

Roberta McIntosh (1843–1869)
Watercolour on paper
1867–1868
350 x 237 mm

Alitta virens, sandworm

A noted watercolour artist, despite her early death, McIntosh provided many of the stunning illustrations for her brother William's groundbreaking volumes on British marine annelids (1873–1923). The published plate of this illustration holds the description 'from an example tossed on shore on the West Sands, St. Andrews, and carried alive to Murthly, where it was drawn'.

Roberta McIntosh (1843–1869)
Watercolour on paper
1867–1868
305 x 235 mm

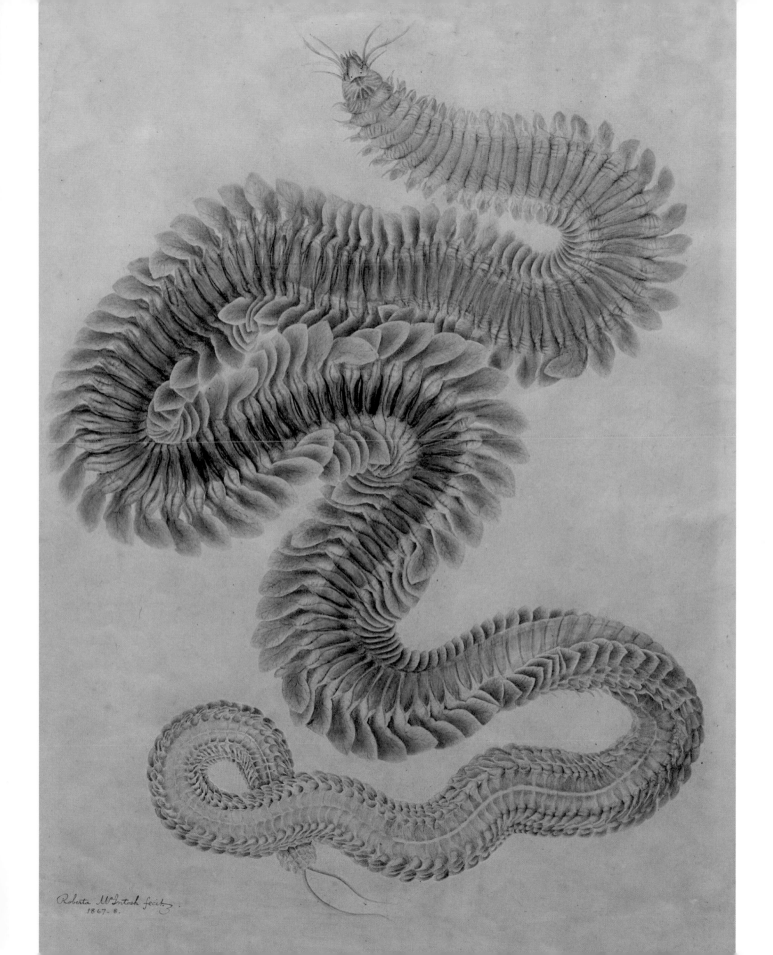

Roberta M'Intosh fecit.
1867-8.

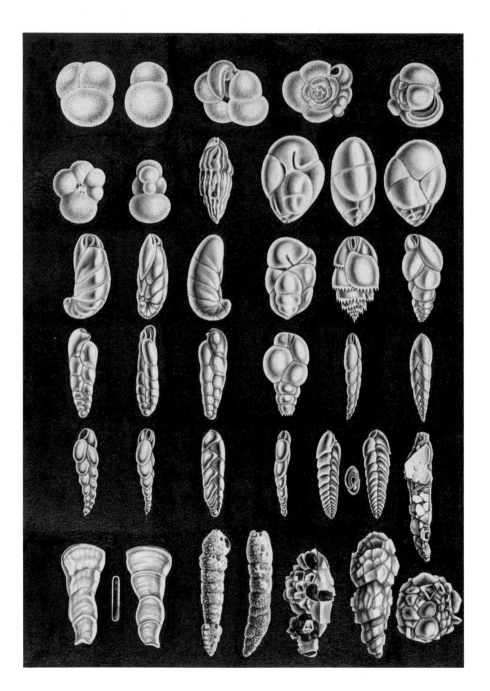

Examples of British benthic and planktonic foraminifera showing various wall structures including agglutinating forms

Edward Waller (1803–1873) was an Irish naturalist, land owner and barrister from Co. Tipperary, Ireland. Swiss-born Wild, official artist on the *Challenger* expedition (1873–1876), was employed by Waller to illustrate seven stunning black and white plates of foraminifera – single-celled protists with shells, the fossil forms of which are studied to help determine past environments. They remain unpublished.

John James Wild (1824–1900)
Watercolour and ink on paper
1870
337 x 250 mm

Cornu aspersum, common garden snail

Cornu aspersum is one of the most widespread snails in the world and they are troublesome pests of crops and ornamental plants. Snails belong to the class Gastropoda and are mainly nocturnal but will emerge during the day after rain. Stubbs was a gifted artist who predominantly painted flowers, his exquisite paintings of shells, however, evoked much admiration among conchologists.

Arthur Goodwin Stubbs (1871–1950)
Watercolour on paper
c. 1906–1940s
162 x 123 mm

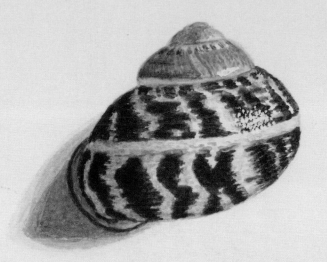
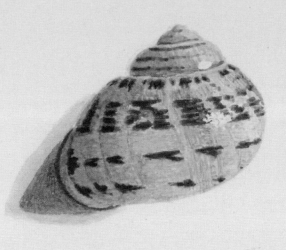
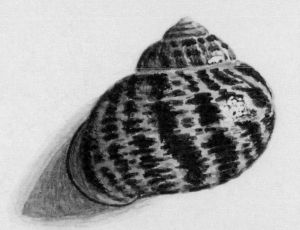

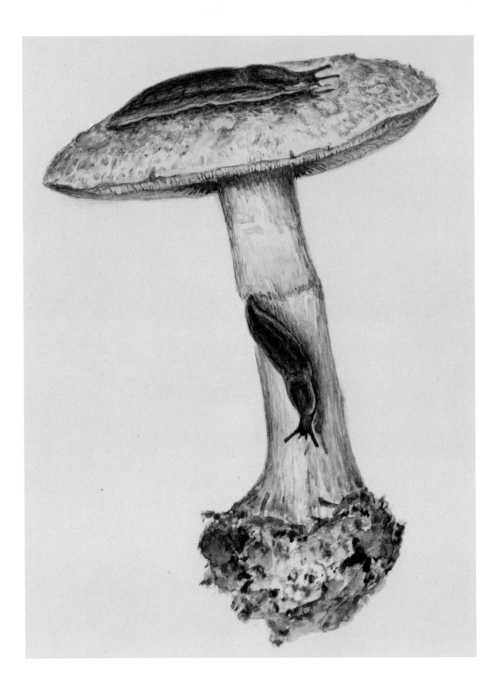

Arion subfuscus, dusky slug

The dusky slug is first male and then female, a condition called protandrous (proto -first, androus -male) hermaphroditism – the clownfish being another example of such an animal. An important distinguishing characteristic of this slug is the yellow-orange body mucus (slime) it produces from glands in its ventral, muscular foot that enables it to glide over rough surfaces.

Rev. R. A. Ellis (dates unknown)
Watercolour on paper
1931
191 x 153 mm

1–4. *Actiniaria*, sea anemones;
5–6. *Scleractinia:* Dendrophylliidae, cup corals

When sea anemones are exposed or touched they draw their tentacles in and the whole animal contracts into a rounded mass. Identification of sea anemones can be difficult and often requires technical dissection to ascertain their correct species name. This illustration was published as plate 34 in the *Observer's Book of Sea & Seashore* (1962).

Ernest C. Mansell (active 1960s)
Watercolour on board
c. early 1960s
262 x 184 mm

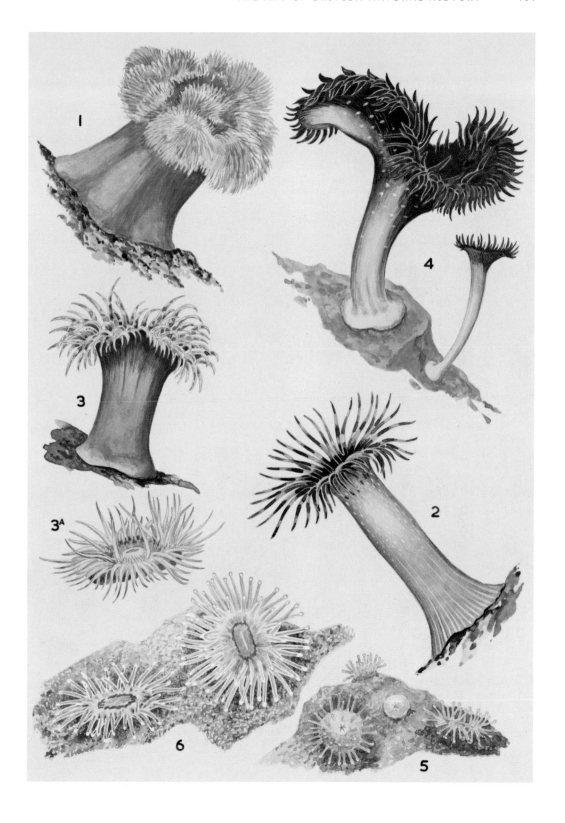

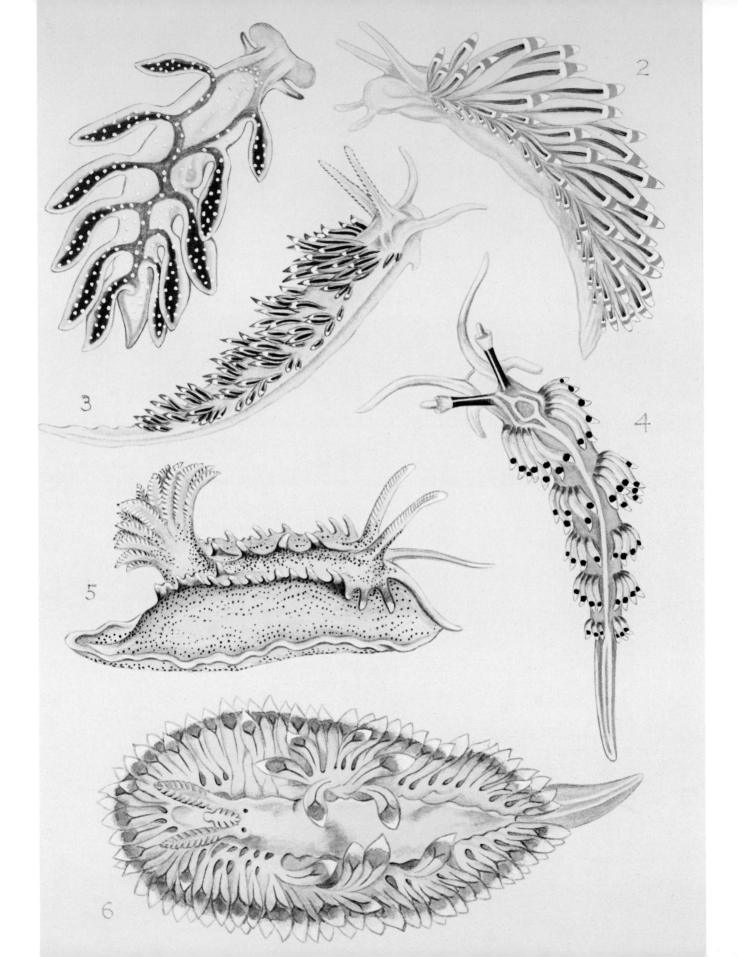

1. *Embletonia pulchra*, Embleton's aeolis;
2. *Eubranchus tricolor*, three-coloured
aeolis; 3. *Flabellina verrucosa*, red-gilled
aeolis; 4. *Favorinus branchialis*, white
aeolis; 5. *Okenia elegans*, venus slug;
6. *Janolus cristatus*, crested aeolis

Sea slugs are some of the most beautiful
marine animals living on British shores. Vividly
coloured and delicate in form, this original
watercolour was published in Nora McMillan's
British Shells (1968) in the very popular
Wayside and Woodland series. Black and white
versions of both of these plates previously
appeared in Edward Step's *Shell Life* (1901)
which McMillan's *British Shells* superseded.

Attrib. Mrs P. Lenander (dates unknown)
Watercolour on board
c. 1960s
231 x 164 mm

1. *Lomanotus marmoratus* marbled slug;
2. *Doto coronata*, crowned sea-nymph;
3. *Tritonia hombergii*, Homberg's triton;
4. *Doris pseudoargus*, rough sea lemon;
5. *Onchidoris muricata*, rough doris;
6. *Goniodoris nodosa*, angled doris

Tritonia hombergi is the largest sea slug found
in the British Isles and can grow up to 20 cm
(8 in). *Doris pseudoargus* is the most common
sea slug found on British shores and is known
as the 'sea lemon'. It feeds mainly on sponges,
especially the breadcrumb sponge, *Halichondria
panicea*, and like all sea slugs it is carnivorous.

Attrib. Mrs P. Lenander (dates unknown)
Watercolour on board
c. 1960s
231 x 164 mm

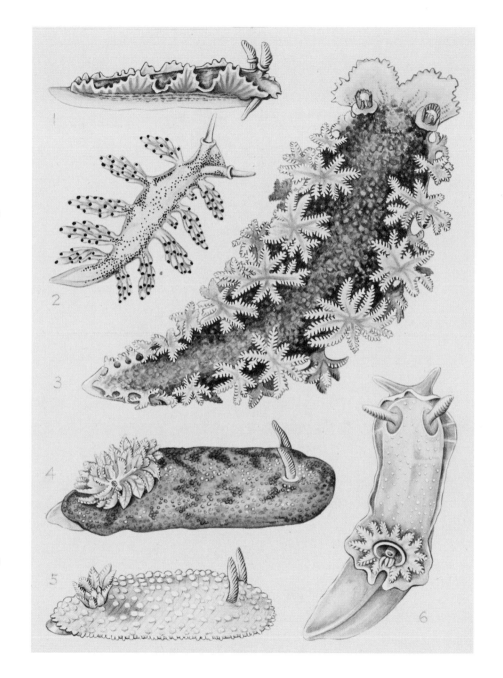

Pebble found on a beach in Eastbourne

Fullwood was a well-known British landscape painter as well as a skilled engraver. He studied geology as a hobby and had a fascination with British pebbles, which he skilfully illustrated in watercolour on blank postcards.

John Fullwood (about 1855–1931)
Watercolour on paper
1916
140 x 90 mm

Pebble found on a beach in Cromer

There are 122 watercolour illustrations of pebbles in Fullwood's album that were chiefly from the south and east coasts of England. In sedimentology, pebbles are described as clasts of rock with a particle size of 2 to 64 mm (0.2 to 6½ cm) – larger than granules but smaller than cobbles. Their composition varies depending upon the rocks they come from, which is why they can vary greatly in colour and texture.

John Fullwood (about 1855–1931)
Watercolour on paper
1920
140 x 90 mm

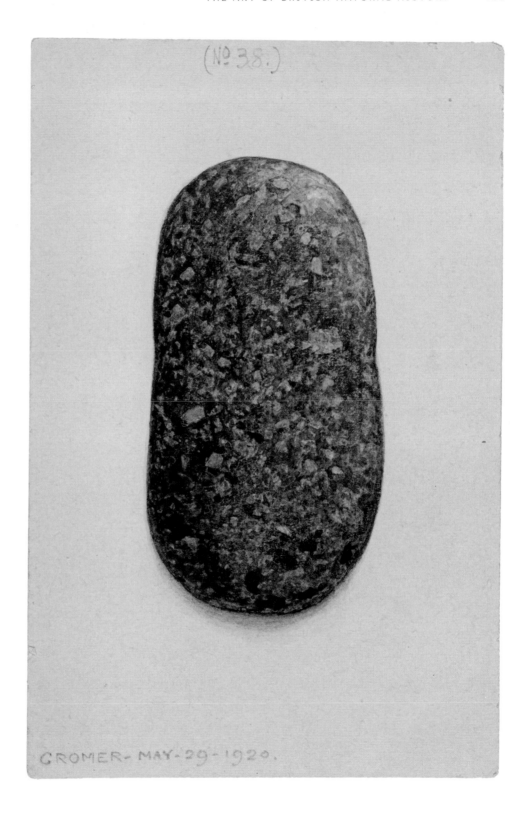

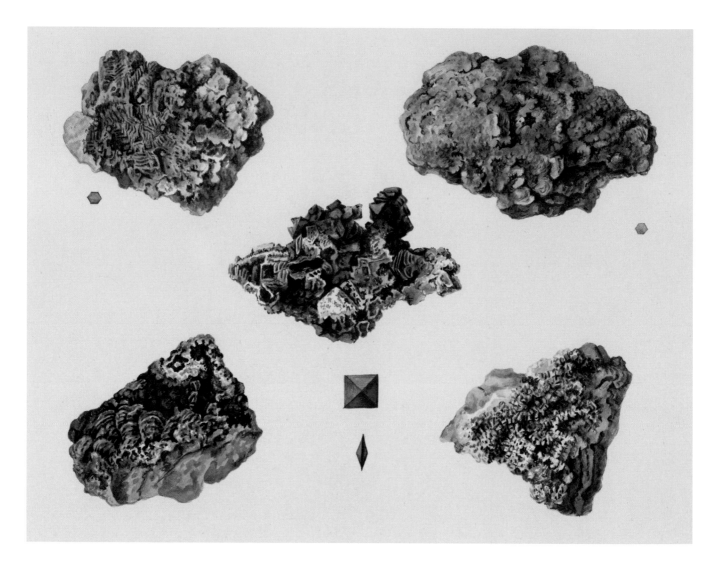

Various copper ores including liroconite, chalcophyllite and clinoclase

Philip Rashleigh's *Specimens of British Minerals from the Cabinet of Philip Rashleigh* represents one of the earliest attempts to accurately portray mineral specimens in their natural colours. Published in two parts, in 1797 and 1802, respectively, it featured some of the most remarkable and scientifically notable British specimens from one of the finest and most extensive private mineral collections ever assembled, some of which were still to be formally classified.

Thomas Richard Underwood (1765–1836)
Watercolour on paper
c. 1800
203 x 250 mm

Lamniformes, shark teeth

The British Isles' fossil heritage is of international importance and they have contributed significantly to the development of scientific thinking regarding prehistoric life. This illustration is from a collection of 54 watercolour drawings of Hampshire fossils, chiefly from Stubbington. No text accompanies the drawings. Fossil shark teeth remain a popular find on British beaches.

J. Holloway (dates unknown)
Watercolour on paper
c. 1800
240 x 155 mm

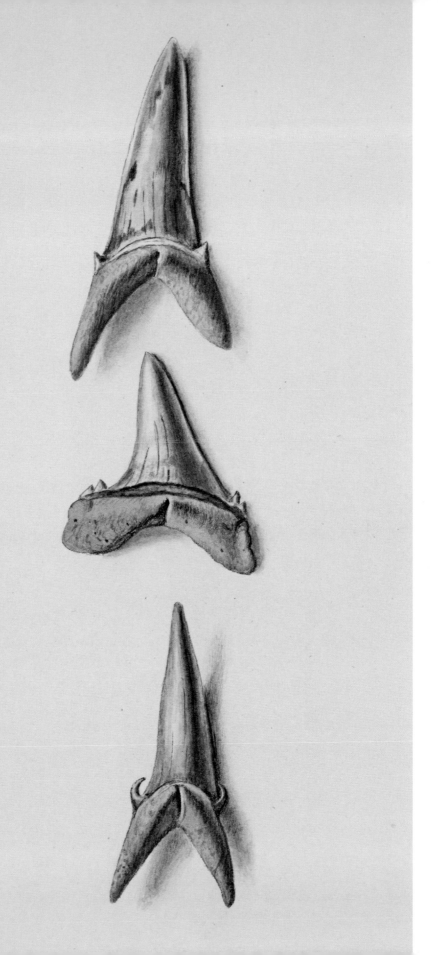

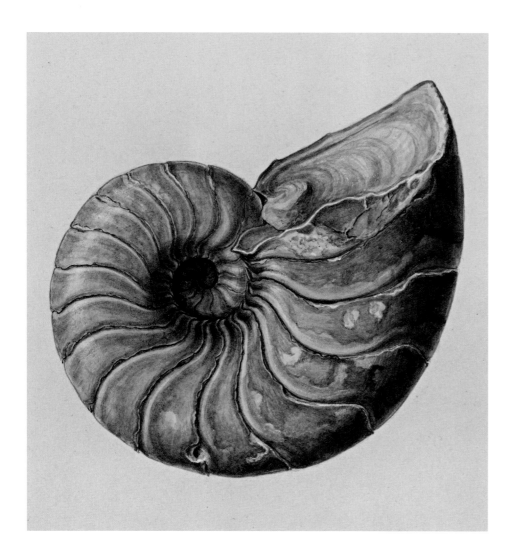

Cenoceras lineatus, nautilus

This illustration is from a volume of drawings of fossil remains from the neighbourhood of Cheltenham that Sowerby undertook for Dr Charles Fowler, a local surgeon. The full scientific name of this nautilus is *Cenoceras lineatus* (J. Sowerby, 1813) as it was Sowerby's father James Sowerby (1757–1822) who first proposed the species name.

George Brettingham Sowerby (1788–1854)
Watercolour on paper
c. 1840
232 x 295 mm

Cystiphyllum vesiculosum, Devonian coral

Perceval collected his Devonian corals from a restricted colony of two limestone horizons in the Ilfracombe Beds in west Somerset. Fascinated by his finds, he spent much time polishing transverse and longitudinal sections of them and it was from these that he painted 11 watercolour illustrations. His large coral collection is now housed at the Natural History Museum together with his mineral collections.

Spencer George Perceval (1838–1922)
Watercolour on paper
c. 1860s
215 x 171 mm

Specimen with numerous branches.

G. Cystephyllum
S. Vesiculosum
L. Withycombe
 West Som[st].
A.16084.

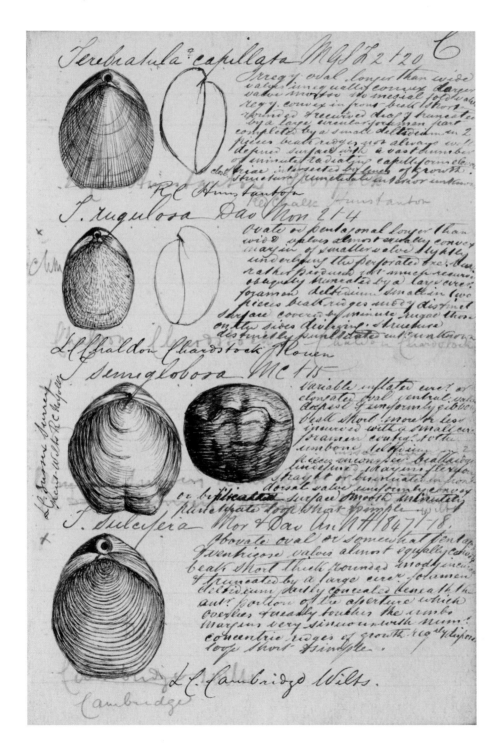

Includes: *Capillithyris squamosa*; *Capillithyris capillata*; *Orntothyris sulcifera*; *Orntothyris sulcifera*, lamp shells or brachiopods

Lamp shells (brachiopods) are a type of shellfish found only in the sea. They are composed of two calcareous shells that resemble clams but have very different soft parts. Fossil brachiopods first appeared in the Cambrian, around 540 million years ago. Brachiopod fossils continue to be actively studied by palaeontologists as they are indicators of past climate change – particularly during the Palaeozoic when they were most abundant.

Caleb Evans (1831–1886)
Pen and ink on paper
c. mid-late nineteenth century
172 x 113 mm

Hypsilophodon

Parker's illustrations show great competency and imagination but with today's increased scientific knowledge of prehistoric animals, many of the features of his subjects are now considered totally inaccurate by palaeontologists. Early hypotheses of *Hypsilophodon* suggested that it could climb, hence many illustrations position this dinosaur in trees. But more recent analysis of the musculo-skeletal structure by palaeontologists concur that it was a ground-dwelling dinosaur.

Neave Parker (1910–1961)
Monochrome gouache and wash on paper
c. 1950s
528 x 370 mm

Index